NATIVE FASHION NOW

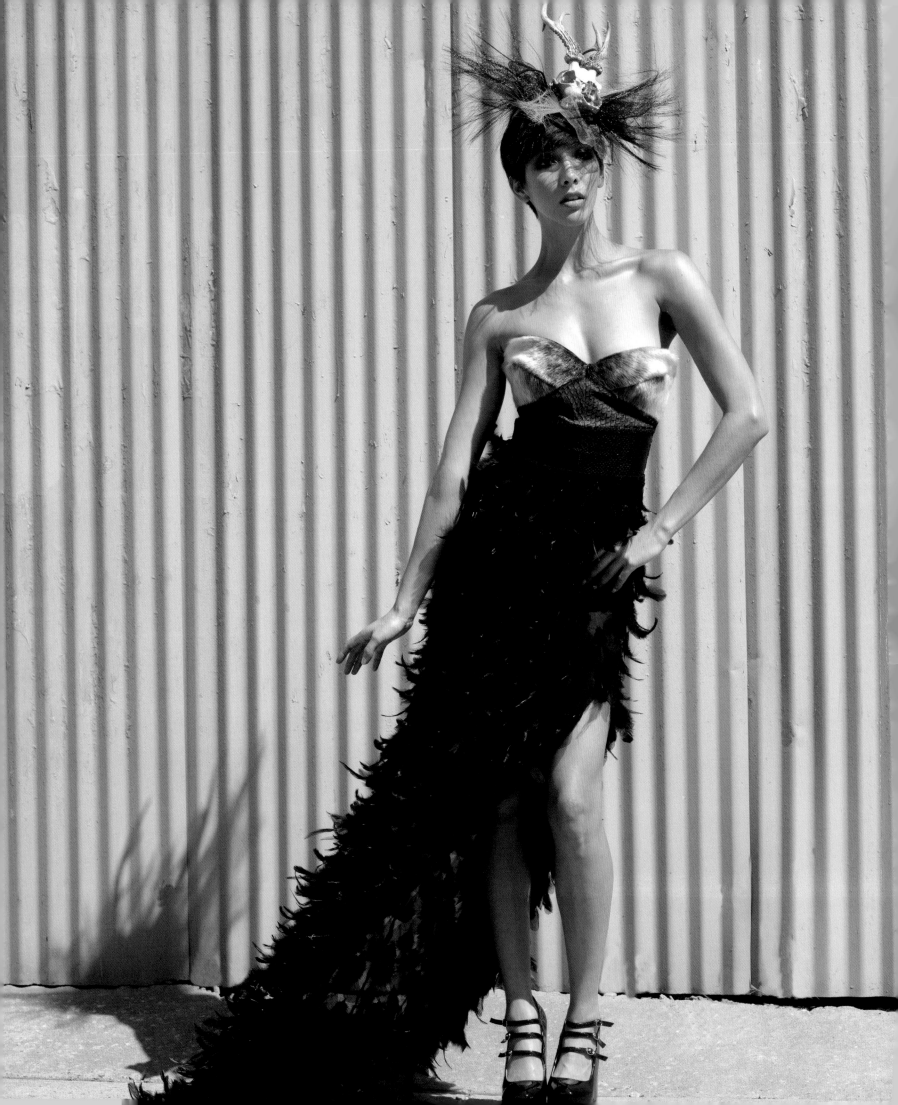

NATIVE FASHION NOW

NORTH AMERICAN INDIAN STYLE

by Karen Kramer

with contributions from

Jay Calderin, Madeleine M. Kropa, and Jessica R. Metcalfe

PEABODY ESSEX MUSEUM, SALEM, MASSACHUSETTS

DELMONICO BOOKS • PRESTEL MUNICH LONDON NEW YORK

CONTENTS

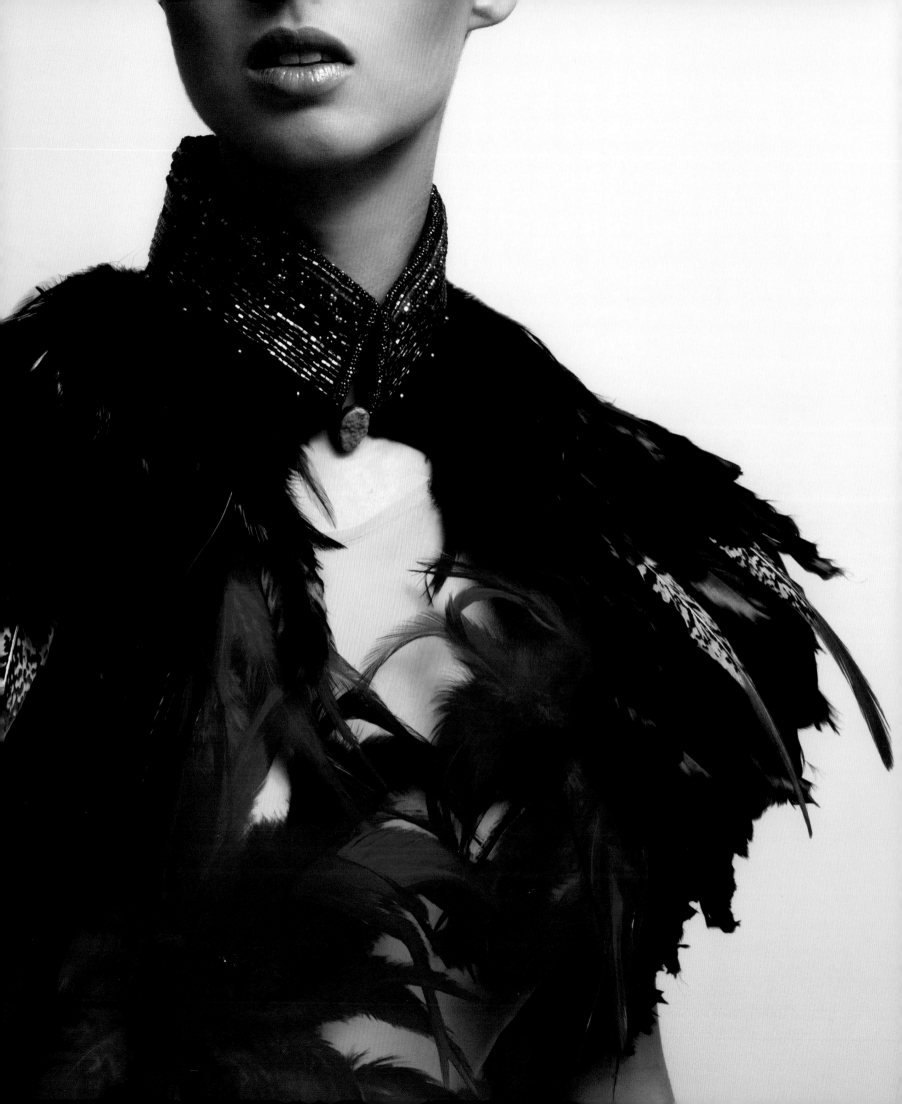

FOREWORD

Fashion is not something that exists in dresses only... Fashion is in the sky,
in the street, fashion has to do with ideas, the way we live, what is happening.

Coco Chanel

it is a time
of visions...
no more do we
hide our dreams
we wear them
on our shirts
round our necks
they make music
in our hair

Karoniaktatie / Alex A. Jacobs (Mohawk), from "Darkness Song"

The Peabody Essex Museum is home to one of the world's oldest and best public collections of Native art and culture of the Americas, initiated with the museum's founding in 1799. Over time, the museum has championed the exhibition, interpretation, publication, and programming of Native American art and culture in more inclusive, expansive ways. Exploring the relationship between historical and contemporary Native expression and collecting contemporary Native art have been central elements in these efforts. Similarly, the Peabody Essex Museum owns one of the country's most extensive and global collections of historic costumes and textiles. And we have recently launched an ambitious modern and contemporary fashion initiative of exhibitions, programming, and collecting to interpret fashion as a form of creativity central to individual, social, and cultural expression.

We are very excited to present *Native Fashion Now*, the first large-scale traveling exhibition of contemporary fashion representing Native designers from across the United States and Canada. Similarly, in moving beyond anthropological and regional studies of Native traditional clothing design and patterns, this project is the first to emphasize the longstanding, evolving, and increasingly prominent relationship between fashion and creativity in Native culture. Parsing the project's title invites consideration of the questions: "What's 'Native Now?'" and "What's 'Fashion Now?'"

The concept of "Native Now" is inherently radical because of a widely held perception that Native American art and culture are phenomena of the past. This not only implies something static and unchanging, it also suggests that Native artistic expression displays little creativity, and is limited in its form and patterns because it emphasizes tradition and convention. In many respects, though, the

(left)
Orlando Dugi
Dress and cape,
"Desert Heat" Collection, 2012

(page 2)
Sho Sho Esquiro
Wile Wile Wile dress, "Day of the Dead"
Collection, 2013

(page 4)
Jamie Okuma
Boots (detail), 2013–14

concept of "traditional" Native American art is a fiction. Native artists honor and respect traditional cultural values, but they have routinely and proactively adopted new forms of expression and materials in response to changing conditions. With advances in anthropological, cultural, and visual studies, we know that contemporary societies have undergone centuries of artistic evolution because culture is fundamentally creative, which means that culture is always changing. Our world, therefore, is comprised of diverse and independent artistic traditions, each of which has undergone centuries of independent and sometimes intersecting evolution. Similarly, the idea of a uniform Native American "style" is hardly possible, given the existence of hundreds of Native American cultures and numerous artists, all spread across great geographical distances. In this sense, Native American art aligns with and also challenges standing definitions of modern and contemporary art as new, of our time, and global.

Stereotypes associated with Western or so-called "mainstream" fashion emphasize the designer as an individual in ways that run counter to the collective expression often associated with Native American culture. In collectivist cultures, people emphasize their connectedness rather than their separateness. Artists are rarely marginalized in Native communities because their works are seen as the highest expression of the group's vision. In individualist cultures—the United States is a prime example—people stress how individuals are different and unique and tend to see themselves as separate from others. Here, artists are considered the epitome of individuality—"more" unique than others, and valuable because of it.

So, unquestionably, a culture's conceptions of creativity influence how creative works develop and are seen and valued, yet it is equally true that artists in collectivist societies display individual style and novelty, and that artists in individualistic societies draw heavily on conventions and traditions. Innovation and tradition are always intimately but also dialectically related. As individualism has assumed a larger presence in Native culture, Native fashion designers navigate this intimate dialectic to express the fact that how we make and wear clothing reflects who we are, individually, culturally and socially.

As to the concept of "Fashion Now," think about how the rising presence of fashion exhibitions in art museums encourages looking at fashion in ways that test its associations with costume, craft, decoration, design, couture, glamour, and style. Is a garment a costume or is it fashion because it reflects a prevailing custom or style in the apparel of a period, country, class, or occupation? Is fashion craft or art, especially if it is made by hand? Where are the boundaries between designing—creating an arrangement of elements according to a plan—and decorating—finishing with ornament? Designing, making, and selling custom-made women's clothing is a gendered domain of couture—how do art and business intersect as cultures that convey the sophisticated and the timely? If fashion delivers the alluring attractiveness associated with glamour, does this mean that fashion emphasizes superficial appearance or is it adept at creating the visual illusions associated with art? And how are the notions of creativity and fashion interrelated when both clearly give shape or form through the use of imagination and ingenuity?

All of these questions assume deeper relevance during a period in which fashion has been noticeably turning away from the Eurocentrism that has dominated this realm since the nineteenth century. Yes, culture and fashion have always been intertwined, and fashion designers have always tapped other times, places, and cultures for inspiration. That suggests a safe, predictable version of globalism,

but what's in the air today is a different, much more pervasive expression of the global that has been growing since the 1960s. Whether in the form of the practitioners themselves or the public recognition of exhibitions and press, Native American, African American, Canadian, Latin American, Japanese, Chinese, and South Asian fashion designers are changing our conceptions of style, identity, and creativity. Aspiring and successful designers are active all over the world and are no longer confined to the longstanding fashion capitals of New York, Paris and London. They feel empowered to emphasize and interpret their national or regional design sensibilities, to assert cultural nuances, and to question and transform rather than simply emulate Western sartorial conventions. Rapid changes in global power and the widening lenses afforded by social and digital media have encouraged countries such as Pakistan and Brazil to foster national fashion industries, while designers in far flung locales are focusing on what people around them are wearing now or wore historically. Nowhere is this more evident than in the ascendancy of the idea of street style, its sense of empowered individuality an intriguing, subversive counterpoint to the customization associated with couture.

Although the concept of curating is prevalent in today's environment of individualized selection, we cannot lose sight of the core concepts of this activity. To curate means to interpret analytically and creatively, whether through focused collecting and research or by presenting the public experiences we call exhibitions and publishing. We congratulate Karen Kramer for the excellence that she has brought to these activities in curating *Native Fashion Now*. Through her considered point of view, Karen invites us into a timely, compelling space—the intersection of culture, creativity, and fashion.

Curating certainly has its solitary aspects, but it achieves its fullest potential in the collaboration that an exhibition represents as its development and implementation call upon the talents and expertise of staff across the museum. We heartily congratulate all who have contributed to making *Native Fashion Now's* installation, interpretation, publication, and programming such thoughtful, engaging experiences. We would especially like to commend Karen's project teammates: Madeleine Kropa, of Exhibition Research and Publishing; Annie Lundsten, of Exhibition Planning; Brittany Minton, of Registration; Michelle Moon, of Interpretation; Jim Olson, of Digital Media; Dave Seibert, of Exhibition Design; and Jackie Traynor, of Graphic Design.

We are gratified to share this endeavor as a traveling exhibition. We thank Brian Ferriso, Executive Director of the Portland Art Museum, Oregon; Randall Suffolk, Director of the Philbrook Museum of Art, Tulsa, Oklahoma; and Kevin Gover, Director of the Smithsonian Institution's National Museum of the American Indian, New York, and their staffs for joining us to bring *Native Fashion Now* to audiences across the country. We deeply appreciate the generosity of the many private and institutional lenders and the invaluable philanthropic support of Caroline and Peter S. Lynch and the Lynch Foundation, the Coby Foundation Ltd., Ellen and Steve Hoffman, Jim and Mimi Krebs, and the Peabody Essex Museum's East India Marine Associates.

THANK YOU!!! and BRAVO!!! to the artists whose works exemplify the dynamism, elegance, and relevance of Native fashion past, present, and future. We respectfully shout out these honorifics in the many languages of North America's Native citizenry. Your works reveal the vision and dreams that creativity fulfills—what can happen, what is happening. We have no doubt that Coco Chanel would agree.

Dan L. Monroe
THE ROSE-MARIE AND EIJK VAN OTTERLOO
EXECUTIVE DIRECTOR AND CEO

Lynda Roscoe Hartigan
THE JAMES B. AND MARY LOU HAWKES
CHIEF CURATOR

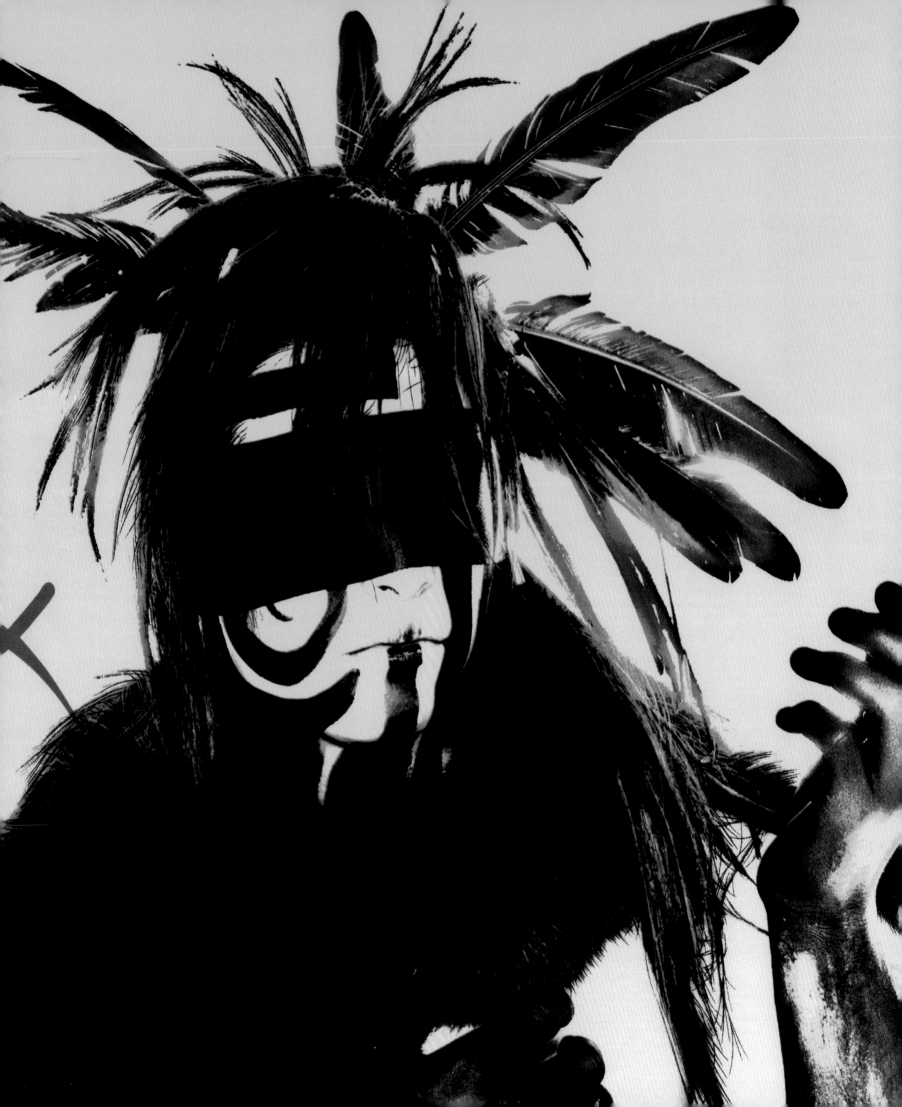

ACKNOWLEDGMENTS

Native Fashion Now stands on the shoulders of dozens of Native master artists, past and present, who have nurtured their creative gifts over time and across generations. It has been an honor to curate the brilliant work of those involved in the project, and I offer my deepest thanks to all of them for the privilege. The exhibition and publication have benefited from the knowledge I gained on previous projects, at the Peabody Essex Museum (PEM) and elsewhere; I extend my profound gratitude to the curators, educators, artists, and mentors whose work has so deepened my understanding and enriched my professional life. I am especially thankful to the many artists, boutiques, institutions, and private collectors who lent works to this exhibition. Thank you for sharing your art with me and with the public. I know it's not easy being without the pieces you treasure, but your sacrifice is our audience's reward.

A distinguished group of advisors helped to advance this project from the beginning. In April 2014, PEM convened a group of fashion designers and scholars to help guide the direction of *Native Fashion Now*. Jay Calderín, Francesca Granata, Jessica R. Metcalfe, and Patricia Michaels offered terrific advice, and their varied perspectives have improved the show immeasurably. Jessica was one of the show's biggest champions, tirelessly tracking down archival resources, forging connections with designers, and sourcing objects. Jay and Jessica, along with assistant curator Maddie Kropa, wrote the object entries for the catalogue, making important contributions to scholarship on Native fashion. In 2014, PEM's Native American Fellowship program brought rising stars from the fields of Native art history, archaeology, and library science onto the project team. The hard work of Kevin Brown (Diné), Stephen Curley (Diné), Crystal Migwans (Wikwemikong Anishinaabe), and Michelle McGeough (Métis) enhanced the exhibition's concept and its content. The 2015 fellowship class arrived late in the project, but never-theless provided valuable assistance. Without all of your careful contributions, this project would not have been realized.

I am indebted to many people at PEM, especially the Rose-Marie and Eijk van Otterloo Director and CEO Dan L. Monroe, deputy director Josh Basseches, and the James B. and Mary Lou Hawkes Chief Curator Lynda Roscoe Hartigan, for their thoughtful leadership and ongoing support. Lynda's unflagging dedication was critical, and I am deeply grateful for her guidance and advocacy. Thank you to Kathy Fredrickson, director of exhibition research and publishing, for her encouragement and adept management, especially on the catalogue. Maddie Kropa, assistant curator, has been a treasured colleague, conduit, researcher, and can-do partner in crime since day one. Maddie's determination advanced this project throughout, while her special brand of pizzazz brought humor to every day. The exhibition's presentation benefited from the work of Michelle Moon, education liaison

(left)
DETAIL FROM PLATE 39
Virgil Ortiz
Scarf, "Indigene" Collection, 2013

and assistant director for adult programs, and from the input of Juliette Fritsch, chief of education and interpretation, and Jim Olson, director of integrated media. Their considerable creative energies brought fresh interpretation to *Native Fashion Now*, while Dave Siebert, director of design, and his staff enhanced the show with their highly engaging and sophisticated exhibition design.

Other PEM staff who contributed significantly to this project include the Exhibition Planning Department's Priscilla Danforth and Annie Lundsten; photographers Walter Silver and Kathy Tarantola; chief marketing officer Jay Finney and his staff in the Public Relations Department: Dinah Cardin, Lisa Kosan, Craig Tuminaro, and Whitney Van Dyke; registrar Brittany Minton, who skillfully oversaw every aspect of the loans; and Claire Blechman, digital asset manager, whose doggedness in acquiring image rights is beyond compare. Thanks also go to PEM's Austen Barron Bailly, Anne Butterfield, Karen Moreau Ceballos, Anne Deschaine, Rebecca Ehrhardt, Dan Finamore, Lynne Francis-Lunn, Barbara Kampas, Amanda Clark MacMullan, Janet Mallett Natti, Mimi Leveque, Dave O'Ryan, Will Phippen, Paula Richter, Trevor Smith, Gail Spilsbury, Chip Van Dyke, and Eric Wolin. Former colleagues Sid Berger, Allison Crosscup, Jamie DeSimone and Claudine Scoville, and interns Madison Vlass and Noelle Villa provided support at key moments during the project. I can honestly say that no one has had better colleagues than I have. Ellen Hoffman, Frank Sayre, Rob Shapiro, Merry Glosband, Jim Krebs, and Dan Elias have been tremendously supportive of my professional development and of PEM's Department of Native American Art and Culture. Their dedication has deeply enhanced my life at the museum.

Editor Sophia Padnos helped to sharpen my writing and my thinking; working with her was a pleasure and fantastic fun to boot. The design and production team at Pentagram, including Clara Scruggs, Kim Walker, and team leader Abbott Miller created the elegant, inspired design. Immense thanks also to Mary DelMonico and her co-publishing team at DelMonico Books · Prestel.

Special thanks are also due to our talented colleagues at the institutions presenting *Native Fashion Now* after its debut at PEM: executive director Brian Ferriso of the Portland Art Museum and his colleagues Deana Dartt and Donald Urquhart; director Randall Suffolk of the Philbrook Museum of Art, together with Christina Burke, Catherine Whitney, and Chris Kallenberger; and, at the Smithsonian Institution's National Museum of the American Indian, director Kevin Gover, along with Machel Monenerkit, Kerry Boyd, David Penney, and Jennifer Miller. We appreciate their exceptional collegiality and the fantastic cooperation we've received from all three museums.

Many private collectors graciously welcomed me into their homes, sharing their collections, their knowledge, and their stories with me, often over delicious

meals. Among them were Kathy and David Chase, Aysen New, Angie and Gregory Schaff, Ruth and Sid Schultz, and Ken Williams and Orlando Dugi. Several colleagues past and present connected me to artists or collectors, sent me articles, edited my work, or just generally encouraged me along the way. They include Janet Berlo, Bruce Bernstein, Janet Cantley, Dinah Cardin, Michelle Finamore, John Grimes, Jessica Horton, Carolyn Kastner, Harold Koda, Ken Williams, Cory Willmott and Catherine Wygant.

Staff at many of the lending institutions were helpful in gathering images and archival materials, but several went to exceptional lengths, notably Ryan Flahive and Rose Marie Cutropia at the Institute of American Indian Arts; Bob Knudson; Mario Klimiades and staff at the Billie Jane Baguley Library and Archives, Heard Museum; and Blain McLain at the Northeastern State University, Oklahoma archives. Thank you to contract photographers Anthony Thosh Collins, Dennis Helmar, Larry Price, and Valerie Santagto and their talented models.

Of course the show could never have been realized without the generous resources provided by *Native Fashion Now*'s funders: the Coby Foundation Ltd., Ellen and Steve Hoffman, Jim and Mimi Krebs, and East India Marine Associates of the Peabody Essex Museum. I am also grateful for the generous acquisition support provided by Katrina Carye, John Curuby, Dan Elias and Karen Keane, Cynthia Gardner, Merry Glosband, and Ellen and Steve Hoffman.

The idea for this project was born in 2012 during a series of conversations with my friend and mentor in all things art and music, Trevor Fairbrother. Trevor, thank you from the bottom of my heart for your great camaraderie and for your spirited blue-sky thinking. Other dear ones who provided support in many forms over the course of this project include: Gavin Andrews, Sarah Chasse, Karina Corrigan, Jennifer Himmelreich, and Paul Nash. As always, my family provides me with endless support, and they, too, deserve special mention: Judy, Andrew, and Tricia Kramer, Sharon and Jerry Malkin, and Don Orne. This book is for my beloved son Mason.

Karen Kramer

CURATOR OF NATIVE AMERICAN
AND OCEANIC ART AND CULTURE

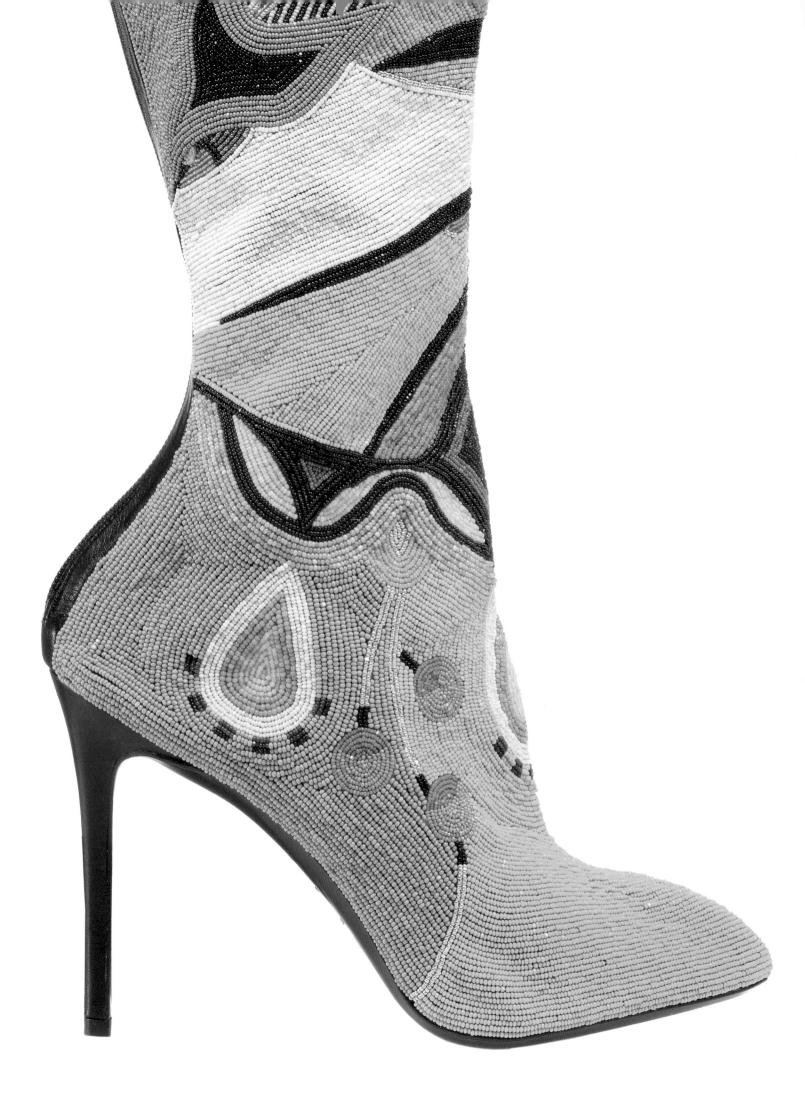

NATIVE FASHION FORWARD

Karen Kramer

I.

Wake up and look around you, because history's in the making. If you haven't noticed, we are right in the middle of a contemporary Native American fashion renaissance. Native designers are beguiling eager fashionistas with some of the coolest, most imaginative and elegant clothing possible. They are inventing new looks, making clothing, exquisite jewelry and accessories that are works of art and that express their designers' identities as creative indigenous people. Native fashion increasingly permeates ordinary life, across the Internet, in stores, at skate parks—pretty much everywhere you might look.

In 2011, Patricia Michaels (Taos Pueblo) took her fashion to the streets. More than a dozen models wearing her latest collection stormed Santa Fe during Indian Market, the world-renowned annual art fair and competition [FIG. 2]. They snaked through the hustle of the crowd in Michaels' otherworldly hand-painted garments, carrying parasols constructed from cedar, metal, and hand-dyed textiles. For Michaels, these parasols are embodiments of prayer, physically and spiritually protective accoutrements that allow her to express an uninhibited inner voice and to make a connection to the natural world. Pueblo principles of balance govern her work, and can be seen in her seamless integration of the handmade and the manmade, and in her innovative techniques of deconstruction and reconstruction. The surprise of the procession, which briefly turned Indian Market into a high-fashion runway, pushed people to look anew at contemporary Native fashion in its active state of becoming.

Michaels' work is so creative and idiosyncratic that it defies clichés of Native design. For many years she was told it did not look "Native" enough, and her work was not accepted into fashion shows. No more. In 2013, when she joined *Project Runway* for its 11th season, she wowed judges and audiences alike, turning heads throughout the fashion world [FIG. 1]. Her diaphanous garments and accessories, including the beautiful *Cityscape* dress, immerse us in her progressive expressions of imagination and worldview [PLATE 1].

(left)
DETAIL FROM PLATE 20
Jamie Okuma
Boots, 2013–14

FIG.1
Patricia Michaels
(born 1966, Taos Pueblo)
Dress and headdress from "Project Runway,
Season 11" Finale Collection, 2012–13

Michaels is not the only one dismantling the familiar in American Indian art—many others are doing so too. It's not so much that they're trying to stir things up, or to destroy stereotypes of American Indians one piece of clothing at a time (though some, like Michaels, certainly are). It's that for the first time, wide audiences can see and appreciate the work of Native designers, who finally have a chance to share their own visions of Native culture and design with a global public. For example, in 2014, a gorgeous model wearing the Kaska Dene/Cree designer Sho Sho Esquiro's dress glided down the catwalk at the Eiffel Tower, while just weeks before, Cody Sanderson's silver Navajo star jewelry was featured at Libertine's show at Mercedes-Benz Fashion Week in New York [FIG. 3]. Indeed, Native fashion designers are decking out—and rocking—the T-shirts, handbags, sneakers, and jewelry of Native and non-Native people alike. And they're knocking it out of the park.

II.

Native Fashion Now is the first major exhibition to engage this movement with all the vitality that is its hallmark. It celebrates the artistic achievements of Native fashion designers from the 1950s onward, taking us deep into the exciting, complex realms of art, cultural construct, and commodity; self-expression, performance, politics and platform. *Native Fashion Now* highlights Native American designers' worldviews, and presents them through different lenses in order to tease out the disjunctions and continuities between them. Overall, the project immerses us in Native fashion today—its concerns, modes of expression, and efforts to create meaning through fashion.

Clothing has always reflected who we are as human beings. What we wear and how we wear it reflects and affects our politics, culture, religion, gender, and class. Like all art, clothing conveys ideas, ignites the imagination, and sparks controversy. The fashion industry is a huge business with a global reach, but at its core is the idea of self-expression through clothing. The goods it produces give individuals and groups an essential way to define themselves.

And Native Americans are no exception. They have used clothing and personal adornment as a key means of artistic expression for millennia. In the West, the business of creating custom clothing (what's now known as "couture") began back in the 1850s, when Paris designer Charles Frederick Worth marketed clothes as status symbols AND works of art. If you think about it, though, Native communities have *always* had couturiers—specialized artists commissioned to create one-of-a-kind objects, often spectacular regalia or ceremonial accoutrements. In the 19th century, the technical and cultural knowledge required to make these objects was handed down through master apprenticeships in dedicated guilds and in family settings. Among Plains tribes, for example, women in quillwork guilds instructed younger workers in the difficult art of weaving with porcupine quills. They sang songs and honored Double Woman, the supernatural being who appears in women's dreams to give them the gift of quill art. Even today, much ceremonial clothing is handmade by such Native couturiers.

In the middle of the 20th century, Native artists began to reach beyond their own communities, and to enter the world of mainstream fashion. The Cherokee designer Lloyd "Kiva" New was the first to create a successful high-fashion brand. In the 1950s, he sold his customized clothing and accessories to a special-

ized clientele across the nation, just as European couturiers had done for decades. He used Native imagery and styles in garments with modern cuts and contemporary color palettes [PLATES 5, 10]. New was a major innovator, but his work was simply the newest iteration of a long tradition of fabulous fashionable expressions by Native people.

Fashion designers often look inward, tapping into their own aesthetic sensibilities and visions of the world. But they must also reach outside themselves for ideas and inspiration. One critical source is history. As Hussein Chalayan, the Turkish-born avant-garde designer, has said, "The garment is a ghost of all the multiple lives it may have had. Nothing is shiny and new; everything has a history. The design is a wish or a curse that casts the garment and its wearer into a time warp through historical periods, like a sudden tumble through the sediment of an archaeological dig." For him, as for many Native designers, looking back but also looking at the present is a way to make great work.

Cultural knowledge and personal life experiences are important sources of creativity—but they are not the only ones. Inspiration can come from any number of disparate sources. Today's Native fashion designers draw from their personal and cultural histories, but also from the world all around them. What makes their creations "Native," or "authentic," is not necessarily the use of traditional motifs or materials; it's the designers' artistic agency, cultural background, and creative ambition.

And while we're on the topic, another note about terminology: labels—not just those in our closets—help us make sense of the world, as we sort through volumes of objects and information all day every day. So let's be clear about our terms here. Although this project presents many artists who fit the conventional definition of "fashion designer," that category is too narrow to contain all the talented artists, past and present, who have contributed to Native fashion in its broadest sense. So while the categories "clothing" and "fashion" are not always identical—in fact, when it comes to teasing out the different ratios of art, capital, and utility in each, they can seem quite distinct—in this project the terms are interchangeable. Likewise, we use a capacious word to describe the ethnic identity of these artists. While most indigenous North Americans identify with their own tribes first, "Native" is an overarching term that many also use to describe themselves. Other words include "American Indian," "Indian," "First Nations," "aboriginal," or "indigenous." The language used in this book follows these choices. It aims to be as inclusive as the show itself, because although not everyone identifies in the same way, everyone has a right to feel comfortable.

In creating clothing and accoutrements, Native designers must constantly negotiate cultural and aesthetic boundaries—some imposed from within, others from outside. They respond to fashion trends, regional tastes, local styles, and sometimes even cultural stereotypes. Yet when Native artists use materials and motifs from their tribal communities, they're sharing their culture and their connection to their ancestral pasts. Although this legacy brings many gifts, today's Native designers are also heirs to 500 years of colonization and their accompanying epidemics, wars, relocations, and social marginalization.

Many contemporary Native artists address these issues in their work. But if they are driven by their cultural history, and by what can be a fraught relationship to mainstream culture, they also find inspiration in outside influences, using contemporary materials, from Mylar to patent leather, to deliver new takes on traditional

FIG. 3
Sho Sho Esquiro
(born 1980, Kaska Dene/Cree)
Calm Waters Run Deep
dress, "Worth Our Wait in Gold"
Collection, 2014; Eiffel Tower,
Paris, October 2014

FIG. 4
Ralph Lauren advertisement, 1981

FIG. 5
Sho Sho Esquiro
(born 1980, Kaska Dene/Cree)
Pendleton blanket jacket, 2013

Pendleton Woolen Mills is not a
Native-owned company, but it does
produce blankets and clothing
inspired by Native textiles. Esquiro turns
its cultural borrowing back on
itself, using Pendleton fabric to make
clothing with contemporary designs
in Native styles.

forms. Take cutting-edge jeweler Pat Pruitt (Laguna Pueblo) who rarely expresses his cultural heritage through familiar Southwestern materials or forms. Rather, his professional background in the body adornment industry shapes his aesthetic, and he cites influences from ancient Egyptian jewelry to contemporary industrial design [PLATES 15, 74]. Pilar Agoyo (Ohkay Owingeh/Cochiti/Kewa Pueblos) is as excited by punk rock, her children's Pokémon cards and Legos, and by her work designing costumes for film and television as she is by Pueblo embroidery and ceramic motifs [PLATE 72]. Other designers, like Kent Monkman (Cree), have fun with contemporary mass fashion. His *Louis Vuitton Quiver*, decorated with the designer's logo, is a quirky mash-up that raises issues of colonization and the consumption of aboriginal identity [PLATE 23].

But while fashion has always been about remixing, and Native designers do it all the time, when outsiders appropriate Native designs and styles, what's good for the goose may not be so good for the gander [FIG. 5]. After all, most fashion based on Native designs is created by non-Native designers. They appropriate Indian style for their own purposes, often using it to assert a kind of "true" American-ness, or to stand for reductionist concepts like "freedom" or "authenticity" [FIG. 4]. Their garments may be handsomely executed; they may raise the profile or prestige of Native aesthetics. But when symbols of Native culture are deployed by people who don't understand their meaning, it's like a game of "Telephone," where the message becomes garbled. After all, the "America" these designs now represent is the same one that has oppressed its indigenous people for so long. Imitating Indian design may be legal according to U.S. copyright law, but it's still a thorny, even a moral issue.

A recent controversy over corporate misuse of Native iconography is an interesting case. Are you familiar with Julius, the cheeky cartoon monkey whose

face pops up on brightly colored Paul Frank products? Well, that little rascal got into big trouble in 2012, when the company hosted an un-p.c. "Dream Catchin'" party for Hollywood's Fashion's Night Out. Julius and many guests had photo booth fun, donning feather bonnets and neon war paint and brandishing fake tomahawks. The outcry was immediate and intense. Native scholars and bloggers Adrienne Keene (Cherokee), of *Native Appropriations*, and Jessica R. Metcalfe (Turtle Mountain Chippewa), of *Beyond Buckskin*, condemned the demeaning stereotypes, and marshaled their online networks to protest. Within days, Paul Frank Industries had apologized for its insensitivity. To make amends, it invited four Native designers to collaborate on Frank's next collection. The result, a year later, was a line of playful, limited-edition clothing and accessories, whose Indian-inspired design was actually created by Natives. This story demonstrates that robust cross-cultural dialogues—even initially hostile ones—can push back on cultural stereotyping, while raising mainstream awareness of healthy alternatives. The collaboration's positive outcome is obvious; now we must rinse and repeat.

Yet controversies continue. If there's one Native design that more than any other has come to represent "Native Americans" in the popular imagination, it's the feather headdress. When sported by celebrities and hipsters, these spectacular objects have great pop impact—but they spark outrage among Native activists [FIG. 6]. For despite (or because of) its status as a universal signifier of "Indianness," the feather headdress has a long and problematic history. Originally worn by warriors of Great Plains tribes during the 18th and 19th centuries, it was a symbol of valor accorded only to tribal members who had shown bravery on the battlefield [FIG. 7]. As historian Philip J. Deloria (Lakota) recounts in his book *Playing Indian*, however, Europeans began appropriating the eagle bonnet for their own purposes almost as soon as they discovered it. Starting at the Boston Tea Party in 1773, it's appeared at events from Boy Scout ceremonies to Grateful Dead concerts, letting Americans of all stripes (even non-Great Plains Natives, who sometimes "played Indian" themselves using said bonnet [FIG. 9]) lay claim to a "true American" identity. Unfortunately, as Deloria notes, it's also associated with some disturbing ideas about America and its relation to its Native populations—ideas that have contributed to Indians' conquest and dispossession.

In the late 19th century, as the frontier closed and that "Old West" faded away, Americans began to feel intense nostalgia for the recent past. Non-Native Americans revisited it in Wild West shows, novels, and later in radio, film, and TV westerns. In these stories, played out against spectacular desert land-scapes, the enemy was always the Indian—riding bareback, dressed in skimpy suede...and wearing the feather bonnet. Again and again, "we," the cowboys, fought "them," the Indians—and again and again "we" defeated "them." In no time, these Hollywood Indians came to represent all Natives, condensing 1,000 communities covering nearly 8 million square miles into one stereotypical image. Distinctions between individuals and tribes were erased: Indians now all looked the same, talked the same, thought the same. The stereotype reinforced the validity of ideas like Manifest Destiny, the 19th-century political argument that the United States had a divine mandate to expand westward to the Pacific, taking over Native American lands as it did so. It also lent credence to the (convenient) myth of the vanishing Indian, tragically sacrificed to the greater glory of a triumphant white America.

FIG. 6
Frank Buffalo Hyde
(born 1974, Onondaga)
In-Appropriate #6, 2013
Acrylic on canvas

In 2012, Supermodel Karlie Kloss wore a provocative Native American–inspired getup, complete with headdress, on the Victoria's Secret catwalk. The ensemble faced immediate backlash for its cultural insensitivity, and was cut from the show's final broadcast.

FIG. 7
Edward S. Curtis
(1868–1952, American)
Oglala Sioux in Ceremonial Dress, South Dakota, 1905
Platinum print
Peabody Essex Museum, Salem, Massachusetts, Gift of Dr. Charles Goddard Weld, 1906, PH76.103

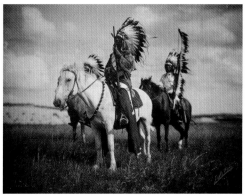

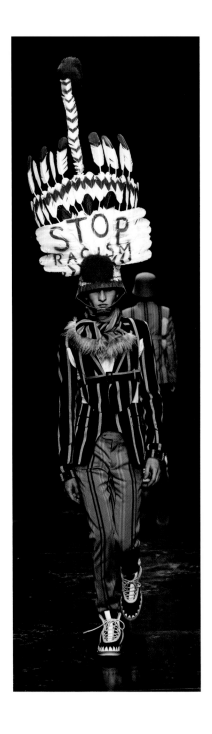

It's these ideas, and this history, that many Natives think of when they see the feather headdress worn out of context. When powerful designers like Jean Paul Gaultier or Chanel's Karl Lagerfeld include them in their ensembles—however striking—they're invoking, and reinforcing, these cultural myths, misunderstandings, and stereotypes [FIG. 8].

That's why it's so huge that Native fashion made by Native people is here now. It's been building ever since New opened his Scottsdale studio in 1946. Contemporary Native designers, like Dorothy Grant (Haida) and Wendy Ponca (Osage), stride through the doors New opened, creating fashion that sensitively blends their cultural iconography and knowledge with great design [PLATES 14, 16]. Others, like scholar, blogger and fashion entrepreneur Jessica Metcalfe, blaze new trails, engaging Internet audiences in critical dialogues while also selling Native-made garments and accessories. Native people are finally speaking for themselves and their tribes—their histories, their family stories, their points of view. As in all

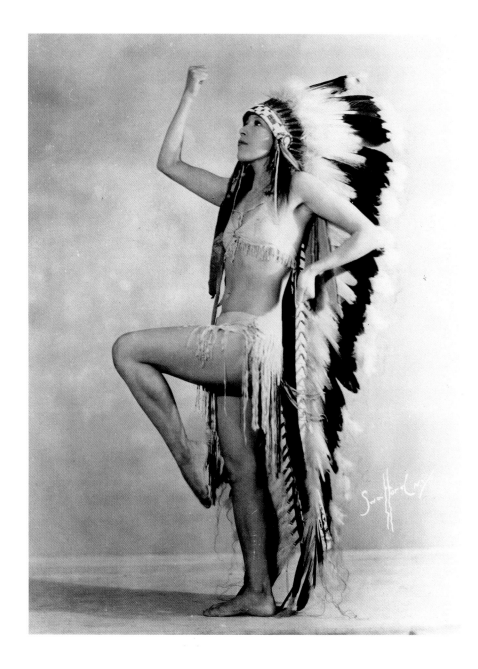

Native art, it's in the telling and retelling of stories that culture is renewed. This is front page, above the fold stuff.

Native designers speak with many voices. There are innovators and traditionalists, activists and aesthetes. Sometimes these categories overlap, sometimes they don't—and of course all artists, if they're worth their salt, have their own unique, inimitable styles. For *Native Fashion Now*, we've staked out four groups of designers based on how they respond to ideas and trends in the world of Native fashion: they are *Pathbreakers*, *Revisitors*, *Activators*, and *Provocateurs*. *Pathbreakers* are groundbreaking designers, while *Revisitors* start by looking backward, then refresh, renew, and expand on "tradition." *Activators* embrace an everyday, personal style that engages with today's trends and politics, while *Provocateurs* depart from conventional fashion to make works that are conceptually driven and experimental. All of them, however, have something important in common: through their work, they demonstrate their own artistic and cultural agency and voice.

PATHBREAKERS

Although a common cliché of Native design is that it's ultra-traditional, many indigenous designers are great innovators. They blaze trails and tear down the boundaries between different kinds of fashion. Although they may swim against a strong cultural current, they have overcome the simplistic notion that Native design must be utilitarian or representational, or must look a certain way. They push beyond the fringe of buckskin and feathers to make garments that incorporate luxurious materials, colors, and patterns, and that more fully represent the contemporary experience of Native people.

Lloyd "Kiva" (the name of his famous label) New is often seen as the father of contemporary Native fashion [PLATES 5, 10]. Trained in art education at the Art Institute of Chicago, he founded Kiva Studio in 1946, locating it in an artisan-run boutique complex in Scottsdale that he had helped to build. The studio operated until 1957, no small achievement given the widespread discrimination against Native people and other minorities during the period. New was more than just the popular kid, although he *was* darn popular, hobnobbing with wealthy locals and tourists, and even celebrities like the Kennedys. He was an original, a visionary, a thinker and a doer. He sold his line far beyond the Arizona desert, in boutiques from Fifth Avenue to Beverly Hills, and even distributed it through Neiman Marcus.

New's luxury leather drawstring handbags, inspired by Navajo medicine pouches, were in high demand almost from the moment he began to sell them [FIG. 10]. Women were spending hundreds of 1950s dollars to buy these coveted, trendy bags and become the envy of their socialite friends. New soon expanded his Kiva label into men's and women's fashions, carving out a signature style based on Native symbols, silhouettes, and color palettes, and experimenting with repetitions of abstract and figural motifs printed on silks and cottons [FIG. 11]. He blended Native aesthetics with sophisticated and flattering cuts. Although he did use traditional Native motifs in his limited-edition garments and accessories, he skirted cultural taboos by carefully avoiding sacred symbols and images.

New was the first Native designer to participate in international fashion exhibitions, beginning as early as 1951. In 1956, his work was featured in

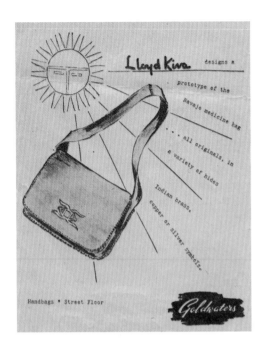

FIG. 10
Goldwaters advertisement for the
Lloyd "Kiva" handbag prototype
inspired by the Navajo "Medicine
Bag," about 1952
The Arizona Republic [newspaper]

FIG. 11
Lloyd "Kiva" New screen printing in his
Scottsdale studio, 1950s

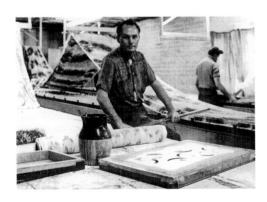

the Museum of Modern Art's *Textiles USA* exhibition alongside goods from other clothing, industrial, and home furnishings companies like Scalamandré Silks, Herman Miller Furniture, and Knoll Textiles. In 1962, at the top of his game, New left fashion retail and began his second career, co-founding the Institute of American Indian Arts (IAIA) in Santa Fe, which promoted his progressive ideas and worked to foster Native American self-determination through cultural heritage, academics, and art. New encouraged IAIA students to step back from the flat, representational style of painting that predominated in Indian art at the time (it was seen as more traditional, and therefore more marketable). New wanted his students to tap into their tribal backgrounds, but also to engage fully with the contemporary world. Papa *did* have a brand new bag—this was the 1960s, after all. Under New's leadership, IAIA hosted numerous fashion shows and created a textile arts curriculum to train students in traditional and contemporary techniques. IAIA offered such classes well into the 1990s; today's IAIA students can still study weaving and sewing in their studio arts classes and independent studies.

Since New's days as a pioneering Native designer, many others have brought his entrepreneurial, innovative spirit into fashion design and Native aesthetics. They source their fabrics globally, and bring their designs to wide markets, achieving recognition far beyond their home communities. Frankie Welch (Cherokee), who designed for many members of the Washington elite from the '60s through the '80s, is one such example [PLATE 8]. A close friend of New's, she collaborated with him on several pieces. But Welch was also a respected designer in her own right, selling her clothes alongside those of other leading designers, from Halston to Oscar de la Renta, at her boutique in Alexandria, Virginia.

Welch's designs were very popular. Made in chiffons, satins, linens, cottons, and synthetics, they were known for elegant patterns that referred to fields from politics (one fabric featured peanuts, in honor of Jimmy Carter) to business (another was decorated with McDonald's golden arches). She regularly incorporated imagery from Native American culture, including jewelry and basketry patterns. In 1966, Virginia Rusk, the wife of Dean Rusk, the Secretary of State, commissioned a scarf from Welch. She asked for something with an "all-American design" to give to visiting dignitaries as a presidential gift. All-American, you say? No problem. Welch created what became her most famous design, the *Cherokee Alphabet* scarf, because, well, what could be more American than a design derived from America's First Americans [PLATE 4]? That was quite a political statement. The *Cherokee Alphabet* scarf was Welch's first, but she ultimately created over 2,000 others, all of which demonstrated her flair for bold graphics and striking design. In recent years, Welch has found an heir in Derek Jagodzinsky (Whitefish Cree), who has riffed on her use of the Cherokee alphabet, incorporating Cree language into a dress and handbag for his LUXX ready-to-wear line [PLATE 3]. Syllabics meaning "We will succeed" repeat on the dress's custom-printed belt and accompanying clutch. The use of these two Native languages as design motifs and political statements reads like a kind of call and response echoed back across time between Welch and Jagodzinzky.

Welch was a hot ticket who had no shortage of success as a designer. You know when you're watching the Oscars, and you realize that the same fabulous designer has dressed more gorgeous celebrities than you even knew were nominated that year? Welch's career was like that. She outfitted five different first

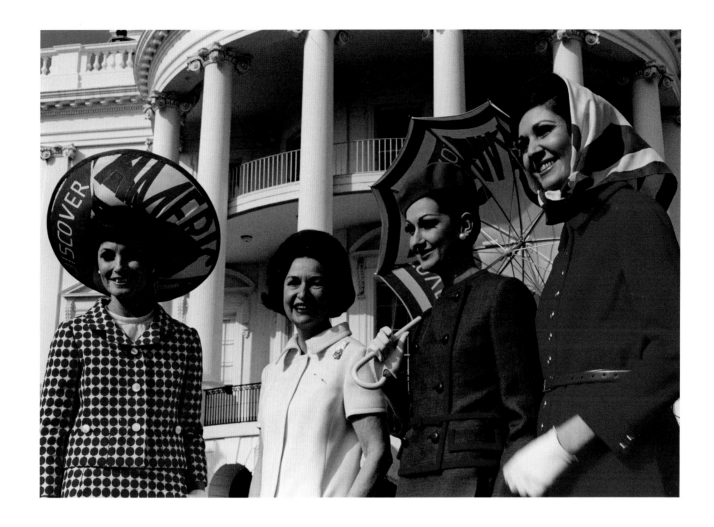

FIG.12
First Lady Claudia "Lady Bird"
Johnson with models
wearing ensembles from the
Discover America collection by
Frankie Welch
(born 1924, Cherokee)
White House fashion show,
February 1968

ladies and designed ties for seven presidents. In February 1968, she also assisted in staging the first-ever fashion show at the White House. It was the entertainment for a luncheon Lady Bird Johnson had planned for governors' wives, to promote her campaign for America's scenic beauty. Models posed throughout the State Dining Room, their hats, umbrellas, and flags emblazoned with Welch's "Discover America" pattern in patriotic reds, whites, and blues [FIG. 12]. Betty Ford so loved one of Welch's dresses (a full-length sequined celadon gown embroidered all over with tiny chrysanthemums) that she chose it for the First Ladies' dress collection at the Smithsonian's National Museum of American History. It's still on view there today.

New and Welch are remarkable for having accomplished so much just a few decades after Native people were punished merely for speaking their own language or practicing their religion. Despite this legacy of cultural oppression, they were able to rise like phoenixes, becoming exceptional artists who found their own voices in celebrating their Native heritage. Their achievements helped create more promising futures for later generations of Native Americans.

Dorothy Grant (Haida) has followed in the footsteps of New and Welch over the course of her 25-year career creating ready-to-wear and couture clothing [PLATE 14]. She launched her label Feastwear at the end of the 1980s, capitalizing on the distinctive graphic quality of her culture's aesthetic. But instead of deploying a Native alphabet, like Welch, or Native-inspired imagery, like New, Grant's work

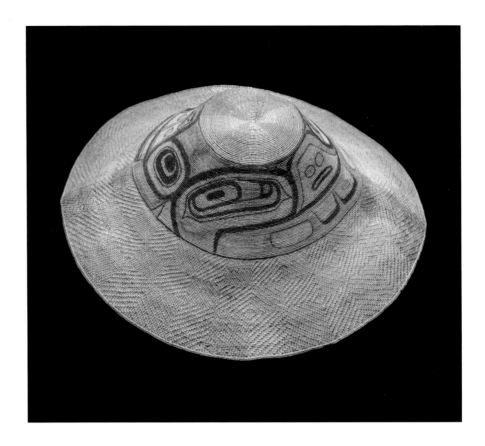

FIG.13
Tlingit artist
Hat, before 1829
Spruce root, paint, and buckskin
Peabody Essex Museum,
Salem, Massachusetts, E3646

draws on the art of "formline," a design style that originated with the indigenous communities of the Pacific Northwest. Formlines are dark calligraphic bands that delineate a figure or create an abstract motif. They may cover a three-dimensional surface (like a monumental totem pole) or take up less than a square inch [FIGS. 13, 14]. Formline designs can depict family crests, humans, animals, or supernatural beings. Grant first used them in clothing in the boxy style popular in the 1980s (although, thankfully, she had the good sense to avoid the shoulder pads, paint splatters, and parachute material so popular at the time). She made them her own by appliquéing formlines from her Haida family heritage onto luxurious leather, silk, cashmere and other fabrics. Haida clan animals like Eagle, Raven, and Killer Whale wrap around her garments and accessories, turning the clothes into kinetic wearable sculptures. While wood carvings and prints have long been ubiquitous in the tourist stores of the Northwest Coast, Grant was among the first Natives in the region to brand and sell clothing inspired by their tribes' exquisite ceremonial garments. She continues to produce compelling fashions for everything from casual weekends to black-tie events.

About a decade ago, Virgil Ortiz (Cochiti Pueblo) was selling his handmade ceramics at Santa Fe's Indian Market when the New York fashion powerhouse Donna Karan strolled up. Ortiz' ceramics are made in the style developed by his ancestors centuries ago: sinuous geometric patterns in black set against ivory backgrounds. Karan was blown away by his bold, vivid forms and motifs, and before long, she had invited him to intern with her in New York. It was kismet, because Ortiz had long been interested in fashion, and had even made his own clothes when he couldn't afford to shop the boutiques of Paris, LA, and New York. Ortiz collaborated on Karan's Spring/Summer 2003 couture clothing line, marrying her silhouettes

and fabrics with Pueblo patterns [PLATE 13]. The partnership between the two designers is an inspiring example of a fruitful collaboration between artists from different cultures and backgrounds—AND of how even corporate fashion can become a vehicle for Native talent.

Since 2003, Ortiz has immersed himself in the world of fashion by launching his own line, Indigene. It produces a range of items, from laser-cut leather jackets, pants, and pocketbooks to cotton T-shirts and silk scarves, all "Made in Native America," as his tagline proclaims [PLATE 39]. Ortiz' work in ceramics inspires his fashion, and his garments often seem to take their cues from the soft yet substantial malleability of clay. Even in his non-fashion work, clothing as an expression of cultural identity is critical.

Orlando Dugi (Diné [Navajo]), is a former competitive powwow dancer with a keen eye for the luxurious detail. He creates visually stunning couture garments and accessories that owe an equal debt to Yves Saint Laurent and to his own Native grandmother, who wore brightly colored velvet blouses, tiered broomstick skirts, and elaborate jewelry every day. Driven by a passion for elegant eveningwear, Dugi experiments with different materials and techniques. His first collection, Desert Heat, features a billowy silk gown in crimson and tangerine, accented with crystals and 24-karat gold-plated beads; it's shown with an equally stunning jet-black feather cape which Dugi created using Cherokee designer Lisa Rutherford's mantle as a foundation [PLATE 6]. Much of Dugi's artistic vision stems from his joyful experiences watching Navajo ceremonies under the night sky; he translates these visions into his handmade, wearable clothing.

No discussion of Native fashion innovators would be complete without jeweler and metalsmith Pat Pruitt (Laguna Pueblo) [PLATES 15, 74]. Trained as a mechanical engineer, he worked in machine shops, and later in the body piercing industry, before starting to make jewelry in the mid-1990s. His materials are radically different from the familiar turquoise and silver of the Native American Southwest. Employing non-precious metals like titanium, stainless steel, and zirconium, Pruitt uses computer-aided technology as well as classic jeweler's tools like files and hammers. His clean-lined pieces are influenced by the contemporary aesthetic of industrial design, fast cars, and tattoos. His use of color is refined; his spectrum of grays and blacks has more nuances of color than a Benjamin Moore paint deck. In Pruitt's *Tahitian Bondage* necklace, pearls roll freely in clawlike pendants. Driven by his passion for personal adornment, and deeply involved in his Pueblo community, Pruitt is an active agent of change in a market where objects are too often valued primarily for their conformity with tradition.

Grant, Ortiz, Dugi, Pruitt, and the other groundbreaking designers dare to dream. Heirs to the past and creators of the future, they defy convention, recounting their stories—personal and cultural histories, visions, dreams—using new media and innovative techniques. Clothing is their language, and they write their sentences in silks and stainless steel, string words together with rhythm, shape, and line. *Pathbreakers* have set in motion new ways of looking at and thinking about Native fashion, along the way creating opportunities for those who follow in their footsteps.

FIG.14
DETAIL FROM PLATE 48
Alano Edzerza
Chilkat tunic, 2013

REVISITORS

Fashion designers are a hungry bunch—perhaps the most voracious consumers of images and ideas out there. *Revisitors* "upcycle," reimagining age-old designs and motifs by using them in new forms. They refresh long-held culturally significant beliefs and images, making them exciting and relevant for new generations. Some of their pieces are made specifically for ceremonies or powwows, and will stay within the Native community. Others are intended for outside markets. But both retain strong elements of the handmade, and are shaped by cultural references that differentiate Native fashion from that of mainstream culture.

The only tradition that never changes in Native art is that things change. Artists rework ancient symbols, forms, and techniques to express contemporary ideas, while also employing contemporary media to revisit ancient values and concepts. While Native art is often seen as radically split between traditional and contemporary modes, that distinction is less relevant to indigenous people themselves. Their cultures, far more than most others, honor the continuity between the past and the present, and work to preserve traditions even as they update them.

In fact, Native artists have *always* brought new media and ideas into their work. Glass beads were European imports, and were initially completely novel, even "high-tech" materials. When Marcus Amerman (Choctaw) beads a portrait of the Lone Ranger and Tonto onto a cuff bracelet, his technique is similar to the one bead artists have used for centuries to stitch floral motifs onto moccasins [PLATE 54]. And like his forebears, Amerman also expresses indigenous experience and values in his work. Native art scholar Bruce Bernstein argues that, for Natives, "tradition" is a set of principles and values that provides a foundation for change, rather than an immutable rule or practice. Artists like Amerman are modern-day tricksters whose work is constantly changing, returning to the past only to update it with a contemporary sensibility.

Revisitors are engaged in refashioning the philosophical and ceremonial continuums that sustain and underpin their communities. After working for years for global designers like Baby Phat and BCBG, Bethany Yellowtail (Apsáalooke [Crow]/Northern Cheyenne) created her own label, B.Yellowtail. For her, making clothes is cultural memory made manifest, and like her ancestors, she works to preserve her culture through clothing. The interplay between dark and light, foreground and background, defines Crow aesthetics and symbolizes balance, a concept Yellowtail aspires to achieve aesthetically and spiritually, even as she makes her life in Los Angeles, far from her Montana home.

Inspired by family heirlooms, from her great-great-grandmother's beaded garments to photographs of her ancestors in elk tooth dresses, Yellowtail created her award-winning *Old Time Floral Elk Tooth* dress, 2014, for her "Apsáalooke" collection [FIGS. 15, 16; PLATE 37]. Elk teeth are the epitome of Apsáalooke wealth and style, symbolic of hunting prowess and prized for their rarity (only two teeth per elk are pure ivory, and therefore suitable for use as decorations). In Yellowtail's dress, a line of these teeth adorns the sleeves, their color and solidity popping against the garment's delicate Italian-made lace. The leather appliqués evoke historic Crow and Nez Perce beaded floral motifs. The dress is a knockout—elegant, sophisticated, and devastatingly sexy. Balancing color, texture, and an incredible range of fabrication techniques, it embodies Yellowtail's

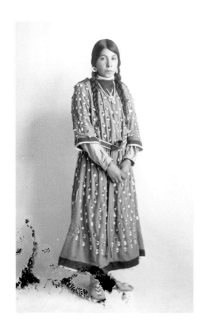

FIG.15
Richard Throssel
(1882–1937, Cree)
A portrait of Rose Bompard Bird,
a young Crow woman, 1902–1933
Glass plate negative
University of Wyoming American
Heritage Center,
Richard Throssel Papers

FIG.16
DETAIL OF PLATE 27
Bethany Yellowtail
for *B.Yellowtail*
Old Time Floral Elk Tooth dress,
"Apsáalooke" Collection, 2014

creative vision and worldview—and shows what amazing things can happen when the past merges with the present.

Designs, styles, and techniques endure even when their creators reinterpret some of their elements. In the late 1970s and early '80s, Margaret Wood (Diné [Navajo]/Seminole) focused on modernizing traditional Native American clothing. She had difficulty finding garments that expressed her identity as a contemporary Native person, so she began her foray into the fashion and fiber arts business. Riding the wave of the macramé-inflected "Indian Style" that was popular in the 1970s (remember Cher in her "Half-Breed" fringe and feathers? [FIG. 17]), Wood adapted historic Native clothing to the trends of the era. She studied dozens of 19th-century Native garments in the Denver Art Museum collection, sketched and schemed, and in 1981 published the first (and until now, only) book devoted to contemporary Native fashion. *Native American Fashion: Modern Adaptations of Traditional Designs* is organized by region, and offers infor-mation on the origins of different clothing patterns. Using new fabrics and altering the silhouettes, Wood made designs that incorporated elements from historical Native dress. For her recreation of the classic 19th-century Navajo blanket dress known as the *biil*, Wood used medium-weight, machine-made wool, empha-sizing the dress's Navajo design aesthetics through the stepped, serrated pattern and the characteristic palette of navy and red. She updated the cut, however, changing it from knee- to floor-length and replacing the one-shoulder style with a bateau neckline [PLATE 36].

Diné (Navajo) designer D. Y. Begay's work pushes Navajo textiles in another direction. An accomplished fourth-generation weaver, she incorporates weaving techniques learned in Peru and Guatemala into her Navajo-style practice, carding, spinning, and dyeing the wool for her projects. After visiting Peru, Begay created her Navajo version of a Peruvian *serape* [PLATE 32]. Its abstract pattern derives from the landscapes of the Navajo homeland, and the design's T-shape refers to the Spider Woman Cross. Spider Woman is an important figure in Navajo cosmology. She taught the Navajo to weave, and she has particular significance for Begay. Paradoxically, Begay has found that using ancient techniques, images, and symbols is the best way to express her experiences as a 21st-century Diné woman.

Native designers see cultural exchange as a critical source of new materials and methods, and their work often responds to trends generated outside Native communities. The dialogue between cultures is central to pieces like *Indian Parade Umbrella*, 1999, by Teri Greeves (Kiowa) [PLATE 22]. Inspired by the parasols used in afternoon parades at the annual Crow Fair in Montana, and by the umbrella her mother always brought to what she called "Indian doings," in this piece Greeves references Plains Indians' appropriation of these European accessories. Fashionable in the late 19th century, parasols were markers of wealth and sophistication. Plains Indians soon adopted them, adding embellishments like glass beads, porcupine quills, and lace. Greeves explains that Indians gave new meaning to these umbrellas by decorating them, and notes that many still use them every day. Greeves takes elements of Plains pictography—two-dimensional profiles of humans and animals, set against blank backgrounds—and adds vivid colors and narrative elements. Her beaded images show contemporary Native people on horses and in vehicles, and are symbolically important representations of this Crow community event [FIGS. 18, 19]. Pictorial beadwork was an important way

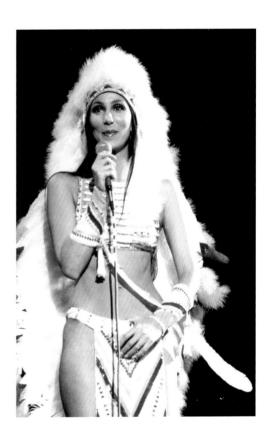

FIG. 17
Cher performing in war bonnet from "Half-Breed" tour, 1975

for Plains artists to express their personal and community pride during the late 19th century; Greeves' work updates that tradition.

Like feather headdresses, moccasins became synonymous with Native American culture in the 19th century. This beaded footwear grew increasingly elaborate between 1890 and 1930, as Native people transitioned to life on the reservation, and glass beads became more accessible. The designs, applied to utilitarian objects like shoes, bags, coats, and parasols, helped to identify the wearer's tribe and social stature. Jamie Okuma (Luiseño/Shoshone-Bannock) began beading at the age of five, and at 22 became the youngest winner of Santa Fe Indian Market's grand prize for her intricately beaded miniature dolls. Her eye for detail and sensitivity to fashion helped her transition into larger-scale clothing projects, and she soon launched her own fashion line, J.Okuma [PLATE 43]. She draws design inspiration from many sources: her own ancestors; ethnohistoric photographs; even the pattern of the carpet at the Bellagio hotel in Las Vegas. She has also repurposed the work of other designers to make something beautiful that is her own. One example is her hand-beaded Christian Louboutin boots [PLATE 20]. She one-upped these luxury items by beading them completely, her slam-dunk to Louboutin's alley-oop. Okuma spent hundreds of hours hand-stitching antique 1880s beads onto them. These beads are of superior quality, and their lustrous, soft colors are no longer produced today. By the time she was finished, only the boots' famous red soles were still exposed—the rest of the surfaces were covered with the beadwork designs of Western tribal communities. The graceful swallows and abstract floral motifs evoke Okuma's childhood on her grandmother's land, and adeptly balance the sharp, slender stilettos. They bring high-top moccasins into the 21st century, and once you see them, you'll never want another pair.

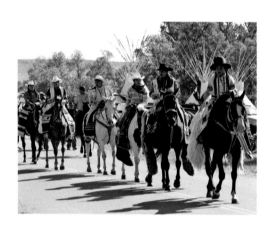

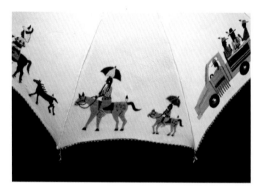

Okuma keeps good company with other artists who are reinvigorating ancestral traditions with each act of creation. Shaped as it is by cultural memory, art strengthens and continues these traditions, expressing a cultural knowledge rooted in ancient understandings of the world. Artists like Okuma express the mundane in extraordinary ways, making tangible objects that represent abstract ideas and practices: prayer, honor, protection, transformation.

ACTIVATORS

"Native Americans Discovered Columbus," declares the slogan on the T-shirt designed by Jared Yazzie (Diné [Navajo]) [PLATE 40]. To protest the Columbus Day holiday, he put out a call for his social media followers to post pictures of themselves wearing the shirt. Dozens upon dozens did. As Yazzie wrote: "I'm rockin the tee today because I am the 500-year resistance. I have been persecuted, stereotyped, hated, and killed. I stand strong with my people. I wear the tee to continue the fight and share truth." Native activists have lobbied to replace the holiday with "Indigenous Day," and for Yazzie, the fallout from Columbus' arrival is personal. The so-called New World had a population in the millions when the explorer "discovered" it in 1492. Yazzie boldly reclaims America as indigenous country, decrying the cultural oppression and loss of land and languages that were among the consequences of Columbus' arrival. For Yazzie, words are weapons that can make people think harder about the truths of history. Anyone, whether Native or not, who wears this T-shirt does so purposefully. T-shirts are especially condu-

cive to the expression of youth culture because they are an affordable, easy and bold outlet for flaunting individuality and expressing opinions.

Fashion as a means of self-representation is a recurring theme in contemporary Native culture, but it's perhaps most obvious with the artists we call *Activators*. These designers blend colors, graphic patterns, and tribal-specific motifs with street-style sensibilities born from the grassroots, not the catwalk or the corporation. The emphasis is on mixing Native-made garments with other items. *Activators* make clothing and style casual-chic outfits with a curiosity and freedom that develops spontaneously, not from some mass-marketing plan. Many younger Native designers are *Activators*, like others of their generation, constantly responding to trends and current events, which are more accessible than ever as a result of social media. Connecting with customers and fellow artists is instantaneous thanks to Instagram, Twitter, Facebook, and Tumblr. Even the seasonal cycles of mainstream fashion don't apply online, where it's an all-access show for anyone who is game. It's a proprietor's delight, a fashion addict's dream.

Like Yazzie, Dustin Martin (Diné [Navajo]) also uses words in his work, words that push us to question history. His 2013 T-shirt references Magritte's famous 1928 painting, *Le trahison des images*, which features an image of a pipe and the phrase *Ceci n'est pas une pipe* below it. Martin's shirt has a picture of a Colt .45 revolver; the motto reads *Ceci n'est pas un conciliateur*, "this is not a peacemaker" [PLATE 46]. "Peacemaker" was the nickname for the .45, a fast-action, revolutionary weapon designed by Colt for the U.S. Army and used, in 1876, by Lt. Colonel Custer and his cavalry in the Battle of Little Big Horn. Although the Indians famously dealt Custer a humiliating defeat in one of the United States government's worst military disasters, they were nevertheless soon exiled to reservations. Martin's T-shirt packs a wealth of historical, art-historical and political references into one compact image. That's a lot of sophistication for an ordinary, inexpensive garment.

Like Martin, Douglas Miles (San Carlos Apache/Akimel O'odham) confronts the unsettled scores of history. He creates Pop Art-style stencils that can be used to decorate clothing, skateboard decks, even street signs or buildings. About ten years ago, Miles founded the first Native-owned skateboard company, Apache Skateboards, on the San Carlos Apache reservation; at the same time, he created the Apache Skate Team to serve the local youth population. The company produces silk-screened skateboard decks and apparel that blends bold, graffiti-inspired graphics with Apache iconography and language. Miles strives to empower Native youth, while highlighting the social issues that confront their communities today. In 2009, Miles collaborated with Volcom, an international sportswear company that was the first to incorporate skateboarding, surfing, and snowboarding products under one brand [PLATE 56]. It tapped into the non-conformist, countercultural spirit of these sports, and when it hooked up with Apache Skateboards, it made sure not to exploit, but to celebrate and promote, Native themes. Miles designed seven pieces for Volcom's 2010 Stone-Age line of clothing and accessories, bringing Apache design to contemporary skate culture. In one design, Miles gave Volcom's beloved skeleton mascot an old-school headband like the one worn by the iconic Native warrior Geronimo. This Apache skeleton holds hunting arrows and, like Geronimo's ideological kinsman Ché Guevara, raises a fist for solidarity. The imagery inspires Native youth across North America.

Seattle-based Louie Gong is a shoe designer of Nooksack, Squamish, Chinese, French, and Scottish descent. He is a self-proclaimed cultural identity advocate who merges art and activism in his customized, hand-decorated sneaks. It all started about six years ago in a spontaneous act of self-expression. Bored with the sneakers available in stores, Gong took a Sharpie to a plain gray pair of Vans, the classic slip-on skateboarding shoes. His designs reflected his mixed heritage, integrating graffiti influences from Seattle's urban environment with formline-style designs derived from his Coast Salish background. Gong's shoes made a splash, and he has since modified more than 200 pairs, sometimes drawing, sometimes painting on them, giving each its own unique contours, colors, and lines [PLATE 51]. Gong's work aims to raise awareness of issues related to mixed-race identity, and he has established art programs in the Seattle area that help kids express themselves by decorating their footwear. On his website, Gong says, "If we can remember 20 different ways to order our coffee, we can remember more than just six terms for describing our identity." In other words, people's identities don't always fit into neat census boxes like "White," "Latino," "Native American," etc.

Gong considers his wearable custom sneakers utilitarian art, and he designs them as his ancestors would have, with artistry, engineering, and precision. Like Gong, Winifred Nungak (Inuit) also expresses her identity in a practical, every-day way—in this case through a winter parka fit for the northern hinterlands [PLATE 45]. Historically, Inuit art took a functional form, expressing itself in useful objects that helped Inuit survive the Arctic's harsh conditions. The last 50 years have been a period of profound change for Inuit communities, as the outside world has increasingly intruded, bringing many outsiders to the region, along with consumer goods and mass media. Like the hundreds of generations of Inuit women before her, who sewed and wore coats designed to combat the unimaginably cold weather in this beautiful but dangerous landscape, Nungak makes art that contributes to the survival—physical, cultural, and spiritual—of her Inuit community. The functionality and aesthetic excellence of her clothing is a remarkable legacy of Inuit seamstresses who have carried on their cultures' traditions. Today women still hand-stitch coats using traditional patterns, though they may substitute cotton or Thinsulate for animal skins. Fringed in hot pink fox fur, Nungak's exquisitely designed coat represents the continuity and rebirth of her community's heritage across generations.

Whether dressing for work or for a night on the town, people project their fashion sense by integrating pieces that express their personal styles and their pride in their identities. Many Natives feel that a critical way to honor their heritage is to present their truest selves to the world through clothing. For Patricia Michaels, this allows you to represent your ancestors, while for Orlando Dugi it is "dressing for the Holy Ones." These artists, and other Natives, dress well to pay respect to the gods and all they have created. Custom-made clothing can also celebrate important life occasions. Thomas "Red Owl" Haukaas (Sicangu Lakota) designed a stunning linen blazer for his friend Kenneth Williams Jr. (Arapaho/ Seneca) to wear to the opening of Williams' museum show [PLATE 44]. Haukaas decorated the jacket in the pictorial Plains style, drawing high-ranking warriors on horseback. Similar narrative images were traditionally painted on 19th-century buffalo hides and tipis, often to record a "counting coup"—an incident of prowess in battle or hunting that brought prestige to the warrior. The designs on this jacket

serve a similar function: Haukaas' riders and horses celebrate Williams' achievements as an artist, the contemporary artist's equivalent of the counting coup.

For the artists we call *Activators*, fashion is a creative means of performing identity. After all, all our clothes are performance pieces—less spectacular, perhaps, but no less meaningful than Lady Gaga's iconic meat dress. What you wear and how you wear it can say a lot—about yourself and about your audience. Clothing frames the act. These designers throw down the gauntlet, speaking with their clothes and demanding that we listen.

PROVOCATEURS

Some Native designers can be thought of as *Provocateurs*. Their sophisticated, conceptual projects—one-of-a-kind clothing and accessories that range from the sculptural to the experimental—push the boundaries between art and fashion. They demonstrate remarkable craftsmanship, incorporating and expanding on tradition, but they also take the old materials, ideas, and forms, and hurl them into an entirely new dimension. They provoke us to rethink and look more critically at charged issues like racism or gender bias.

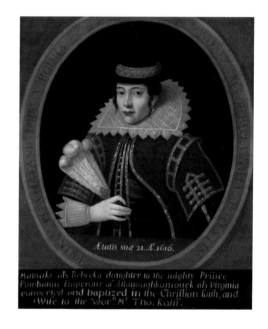

The multidisciplinary work of Wendy Red Star (Apsáalooke [Crow]) draws attention to the marginalization of Native people and to other social issues. A gifted seamstress who is inspired by vintage clothing, family snapshots, and the 19th-century couture of her Montana Crow tribe, Red Star explores the intersection of reservation life with that of the outside world. In 2013, she collaborated with Terrance Houle (Blood) to create their installation *Síkahpoyíí, bishée, baleiíttaashtee (Motor Oil, Buffalo, Dress)* [PLATE 66]. Red Star's dress stands in a gallery before vinyl buffalo silhouettes designed by Houle. The piece draws attention to the exploitative economy of natural resource extraction on Native lands, evoking the environmental destruction that oil and gas drilling has wrought on millions of acres of habitat. Many Great Plains tribes have long regarded the buffalo as their sacred kin, and depended on it for food, shelter, and ceremony. Now the species, which had come back from near-extinction in the 19th century, is again threatened, this time by the insatiable hunger for energy. The vinyl drips from Houle's black buffalo suggest both trickling oil and leaking blood, and the piece provides a powerful complement to Red Star's long, trailing fringed dress and elaborate breastplate.

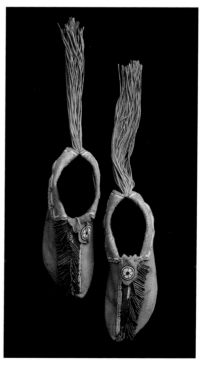

How is it possible that Kent Monkman (Cree) can simultaneously address multiple huge topics—like gender politics, Native identity, and the colonization of aboriginal people—in one unassuming object the size of a large house cat? The answer is: with the *Louis Vuitton Quiver*, 2007, the purported possession of Monkman's alter ego, Miss Chief Eagle Testickle [PLATE 23]. The character's name plays on the words mischief, egotistical, and testicle; Miss Chief is physically male but identifies as female. Miss Chief belongs to a tradition of "two-spirit" figures historically revered within Native communities (though reviled by outsiders). Two-spirits dress as and behave like members of the opposite sex. Miss Chief plays a starring role in Monkman's paintings, films, photographs, and performance pieces, wielding arrows like the ones in this high-end luxury brand accessory like any good 21st-century glam Indian warrior-princess should. Hunter of men and irony alike, Miss Chief carries the quiver in several of Monkman's photo and film

works, which riff on early 20th-century studio portraits and silent movies. More than a mere prop, the quiver, like the other objects Monkman creates, stands against the legacy of stereotyped representations of Native people generated by anthropologists, explorers, and artists. He interrogates the past by mixing it up with the present, and he does so with humor and sass.

Lisa Telford (Haida) has mastered the centuries-old art of weaving with cedar bark and spruce root. Her one-shoulder sculptural dress *PochaHaida*, 2009, has an asymmetrical, curvaceous silhouette, accented with leather fringe—an elegant blend of Haida and European design. Its title makes playful reference to Pocahontas, the Indian maiden we remember from elementary school social studies and Disney movies. Although the real-life Pocahontas is a complex figure, this dress plays on her popular image as a pure yet sexy and strong Indian princess [FIG. 20]. Working in woven red cedar, Telford takes traditional Northwest Coast basketry forms into new territory, playing with the idea that Native weaving is only for functional objects [PLATE 68]. The dress reminds us that textiles have long played a pivotal role in Northwest Coast indigenous ceremonies and cultural exchanges, communicating important messages about status and worldview. It's a complex object, a beautiful garment that raises questions about its own function. Could it really be worn? If so, how would it feel on the body? Telford has made other sexy cedar bark clothes—a bustier and high-heeled shoes, for example. All are awesome feats of weaving technology, as well as interesting artworks that take on key questions of aesthetics vs. utility.

In his work, Barry Ace (Anishinaabe [Odawa]) considers the confluence of past and present, using material and form as a platform. His respect for the Great Lakes artists of the past, who incorporated new trade materials like glass beads, silk ribbon, and wool cloth into their creations, is evident throughout. He replaces beads with reclaimed computer parts, including transistors, resistors, and capacitors, extending his community's tradition of using new technologies to communicate their view of the world. For *Reaction*, 2006, Ace embellished the Kenneth Cole shoes he wore during the late 1990s as an employee of Canada's Department of Indian Affairs, adding a fringe made from copper computer wire [PLATE 73]. The department was cracking down on the personal use of government computers, and staffers were frantically erasing their hard drives to cover their tracks. The decorated shoes refer to the moccasins of 19th-century Plains warriors, which had fringe designed to trail along the ground, erasing the wearer's footprints as he walked [FIG. 21]. "Reaction," the brand name for Ace's shoes, gives the piece its title; it suggests the idea of responsiveness that Ace sees as an important theme in his work.

Patricia Michaels is another artist who is inspired by the world around her. Her *Cityscape* dress, which vaulted her to the forefront of the competition during *Project Runway's* 2013 season, is at once minimalist and chic, evoking Manhattan buildings reflected in water [PLATE 1]. It features an abstract pattern of shadow and light that Michaels created using feathery brushstrokes of paint on cut leather. The dress is an homage to Agnes Martin and to Georgia O'Keeffe, two influential women artists who, like Michaels, worked both in New York and in the Southwest [FIGS. 22, 23].

Michaels was exposed to many Native cultures as a child, and she incorporates their imagery in her work. Tiny blue paint specks recur throughout her textiles, representing water, a life-sustaining force in the arid Southwest and a substance

FIG.22
Agnes Martin
(1912–2004, Canadian/American)
Orchards of Lightning, 1966
The William S. Paley Collection
The Museum of Modern Art, New York

that is also very important to Michaels. Her clothing, like that of her mentor Lloyd New, also refers to other rich colors in nature. The Japanese fashion pioneer Issey Miyake has been another touchstone for Michaels since her days studying fashion at the Art Institute of Chicago in the 1980s. Miyake has long pushed the boundaries of Western beauty, and Michaels shares his affinity for loose-fitting fabrics, abstract shaping, and asymmetrical hemlines. Their clothes fall softly away from the body—there is no "bad hair day" equivalent when wearing either Miyake or Michaels' PM Waterlily (the name of her most recent line, taken from her Pueblo name, Waterlily).

Michaels' stints as a costume designer at the Santa Fe Opera and as an apprentice for an Italian tailor in Venice are reflected in her work. She also celebrates the tapestries of the Hopi artist Ramona Sakiestewa, whose painterly work moved Native textile design beyond the functional. For Michaels, making fashion is a meditative process, from drape to pattern to fabrication. She constructs and deconstructs not only materials, but also concepts of beauty and what Native fashion can be.

III.

With fashion, everything comes full circle. What is old is new again, and what is new now will soon be old. And so it goes. Native designers will continue to reach back to the past and forward to the future, creating clothing that reflects their personal, cultural and aesthetic identities.

Native fashion designers are infiltrating the larger fashion world in new ways. They make use of postmodern strategies like appropriation, affirmation, and irony. They pierce through expectations with Mylar and graffiti, silk scarves and gala gowns alike. Native designers are engaged in a dialogue between material and concept, question and answer. They are busy writing the next chapter on contemporary fashion while we eagerly await their new lines. The proliferation of Native fashion now dances between performance and social construct, art and commerce.

Native fashion creates new visual languages and contributes to a larger dialogue on issues of identity, sovereignty, and creativity. Native designers translate their lives for us in fabrics, shapes, and colors while they generate new impulses for understanding themselves and the world around us. They move forward with a renewed sense of freedom, applying creativity and voice with confidence. Fashion—like art, like culture, like life—is constantly moving. Native fashion designers will continue to demonstrate what a powerful tool fashion is for the expression and vitality of Native people in today's world—and how it's always changing, faster than a New York minute.

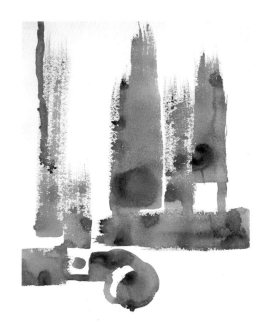

FIG.23
Georgia O'Keeffe
(1887–1986, American)
Untitled (Abstraction Blue Shapes), 1970s
Gift of The Georgia O'Keeffe Foundation
Georgia O'Keeffe Museum, Santa Fe
2006.05.537

PATH-
BREAK-
ERS

Patricia Michaels

Taos Pueblo

—

Fashion designer Patricia Michaels created this dress during her time as a contestant on the hit reality television show *Project Runway*. The show pits designers against each other in a series of challenges; the task here was to create a garment incorporating a representation of New York City.

It wasn't a stretch for Michaels, whose work embodies a strong sense of culture and of place, and is often concept-based. Taos Pueblo and pan-Indian powwow adornment practices are strong influences, but so are the visual arts and fashion itself. In this dress, Michaels imagines the lighted windows of New York buildings reflected in water—then translates her vision into a dress. She hand-painted luxurious white leather with silver-grey paint, then cut slits into it to reveal the cobalt blue fabric underneath. The design is sleek and chic, with an artistically rendered geometric pattern that feels simultaneously representational and abstract. The slits in the fabric give the dress a tactile quality, changing its appearance as the wearer moves. The show's judges applauded Michaels for her artistry and her clever manipulation of fabric, and placed the dress among the competition's top three selections. – JRM

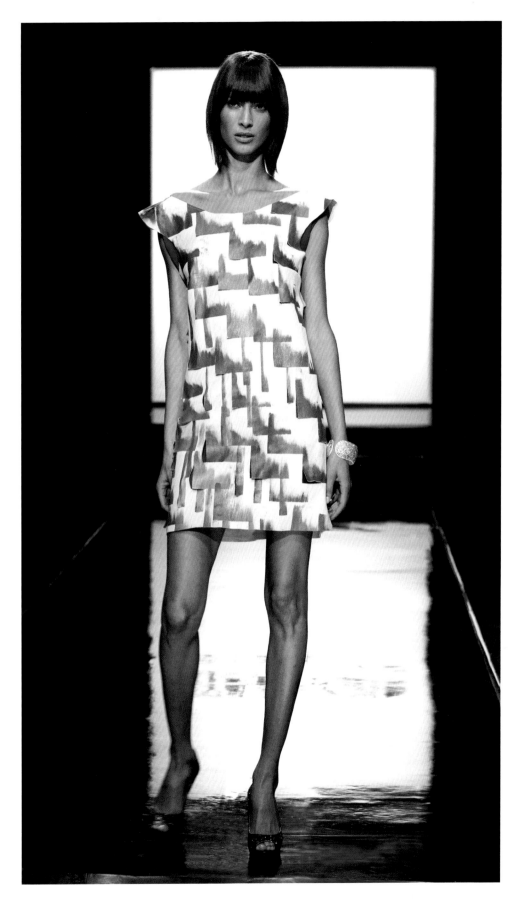

PLATE 1
Patricia Michaels
(born 1966, Taos Pueblo)
Cityscape dress, "Project Runway, Season 11"
Collection, 2012; Leather, paint, and silk
Courtesy Kathryn Rossi

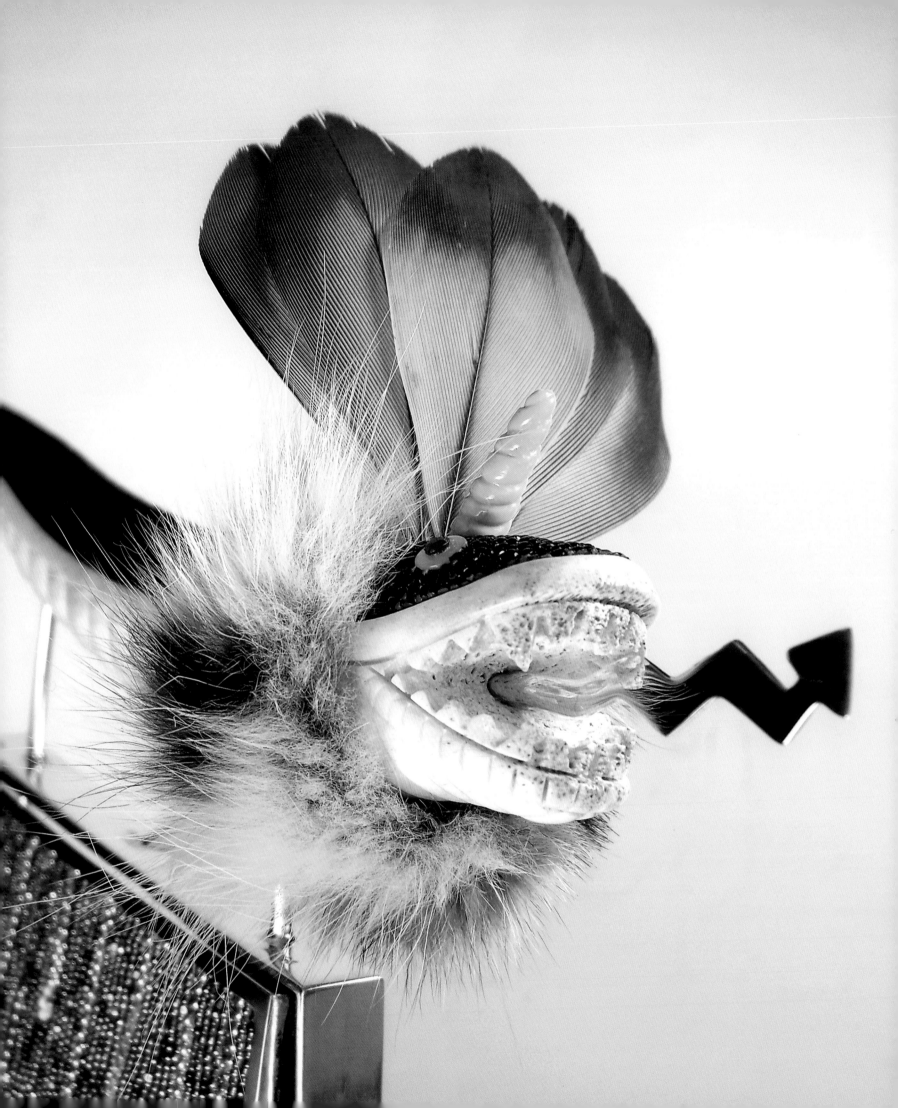

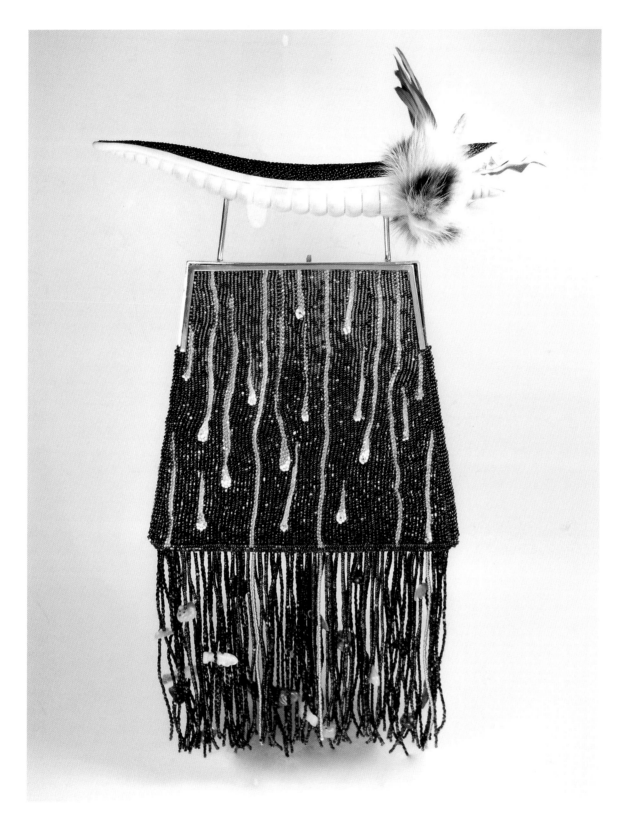

PLATE 2
Orlando Dugi
(born 1978, Diné [Navajo]) and
Troy Sice
(born 1977, Zuni)
*The Guardian—Bringer of Thunder, Lightning
and Rain* handbag, 2013; Elk antler,
stingray leather, parrot feathers, bobcat fur,
rubies, shell, glass beads, and sterling silver
Courtesy Ellen and Bill Taubman

Derek Jagodzinsky
Whitefish Cree

—

Cree syllabics swirl around the waist
of this fringe dress, encircling the
wearer at the center of her body, her
being's core. The dress celebrates
the Cree language, still spoken daily by
tribal members in Canada despite
past government efforts to suppress it.
Its appearance on the runway is a
testament to the power of indigenous
endurance. Derek Jagodzinsky's
international recognition as an emerging
couturier makes it clear that these
dresses also send the message "We
will succeed." - JRM

PLATE 3
Derek Jagodzinsky
(born 1984, Whitefish Cree)
for *LUXX ready-to-wear*
Dress, belt, and handbag, "Four Directions"
Collection, Spring/Summer 2014
Spandex-synthetic blend
Courtesy the designer

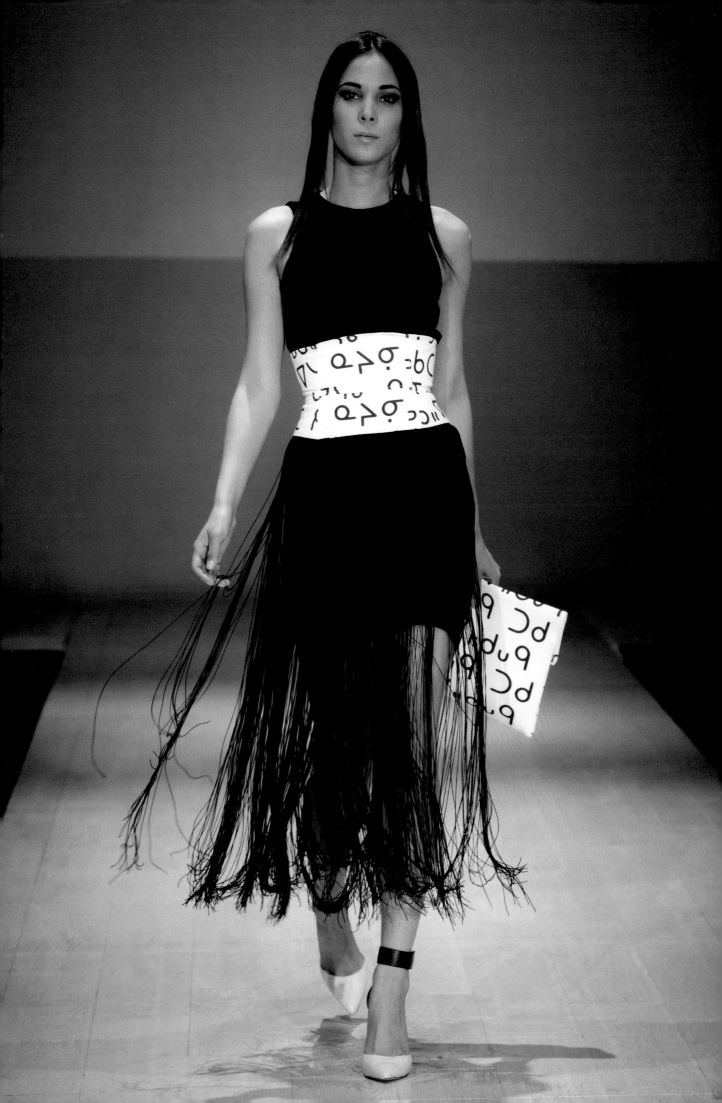

Ꮜga Ꭷka	Ᏹgi	Ꭷgu
Ꮣha	Ᏽhi	Ꮁhu
Ꮃla	Ꮈli	Ꮀlu
Ꮉma	Ꮀmi	Ꮋmu
Ꮎna Ꮏhna Ꮐnah	Ꮒni	Ꮕnu
Ꮖqua	Ꮗqui	Ꮙquu
Ꮜsa Ꮝs	Ꮟsi	Ꮡsu
Ꮣda Ꮤta	Ꮧdi Ꮨti	Ꮪdu
Ꮥdla Ꮮtla	Ꮳtli	Ꮩtlu
Ꮳtsa	Ꮸtri	Ꮴtsu
Ꮺgwa	Ꮻmi	Ꮽmu
Ꮎya	Ꮿyi	Ꮾgu
Ꮄe	Ꭴo	Ꭵv
Ꭼge	Ꭺgo	Ꭱgv
Ꭾhe	Ꭶho	Ꭿhv
Ꮊle	Ꭹlo	Ꭷlv
Ꮄme	Ꮝmo	
Ꮞne	Ꮓno	
Ꮺwe	Ꮴnv	

Frankie Welch

Cherokee

—

Languages are at the core of human identity. By the 1820s, the Cherokee leader Sequoyah had developed a written syllabary, or alphabet, for his community. It was the first written form for any Native American language, and its invention has been a point of pride ever since. A hundred and fifty years later, Frankie Welch created a fabric pattern from it, producing garments and accessories that became popular with Washington's political elite. The bold, graphic qualities of the syllabics create a striking visual effect; and emblazoning a Native language on scarves, jackets and other items worn by U.S. leaders sent a powerful—if subliminal—message about the value of Native cultures in America. —JRM

PLATE 4
Frankie Welch
(born 1924, Cherokee)
Cherokee Alphabet scarf, about 1970
Printed synthetic
Peabody Essex Museum,
Salem, Massachusetts,
Gift of Karen Kramer, 2015.11.3

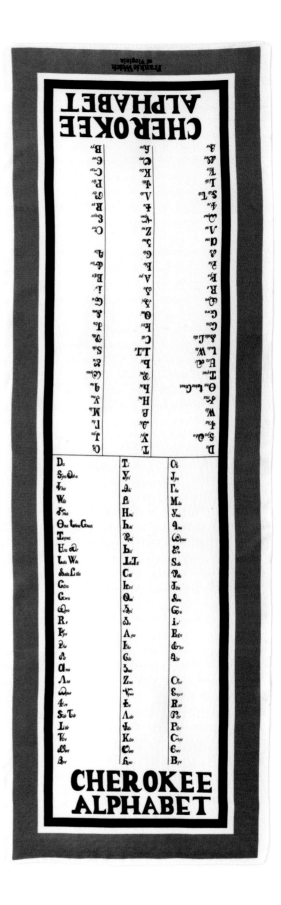

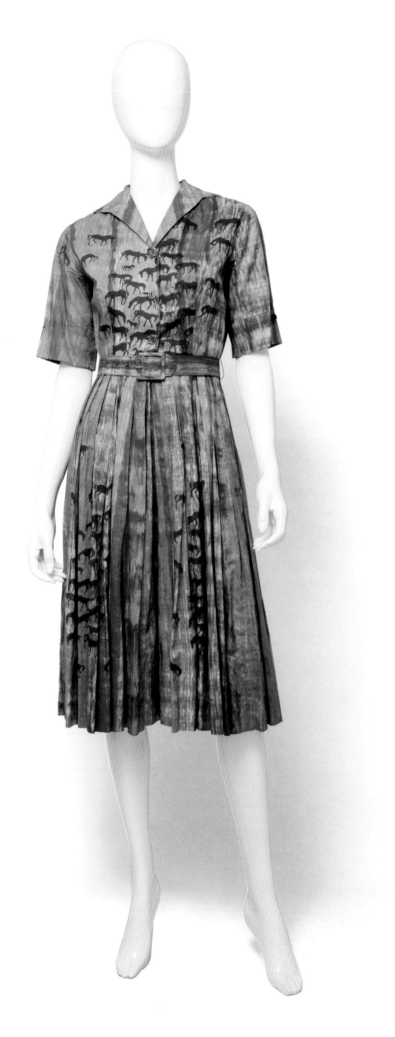

Lloyd "Kiva" New
Cherokee

—

Who knew that desert scrub could inspire such an elegant look? Lloyd Henri New knew, that's who. River beds, cliff striations, and even, yes, the vegetation of the desert Southwest—they all provided inspiration for his label Kiva. Although New designed this fitted sage-green dress, other Native artists painted its horse motif (Andrew Van Tsinajinnie, Diné [Navajo]); silkscreened the pattern (Manfred Susunkewa, Hopi); and made the buttons (Charles Loloma, Hopi). New's collaborative approach to manufacturing may echo that of haute couture, but it was also just an efficient way to fill the orders of all the American ladies clamoring for anything Kiva.

This style, known as the "squaw dress," was popular in the 1950s (the name's now out of fashion, even if the look isn't). This Southwest-influenced staple of summer attire was ubiquitous at the period, dreamt up by New and the Arizona Fashion Council as a lovely and authentically American variation on the then-popular 'New Look' silhouette by Dior. It was a perfect fit, with its cinched waist and full skirt, and its origins in Navajo broomstick skirts and Mexican dresses. When designers in New York copied it, New encouraged customers to purchase the real deal: as he told the *Winona Daily News* in 1955, "These fashions were born in the West. Out here, we know how to make them. These are a modern expression of an ancient primitive art. Imitations always look phony." -JRM

PLATE 5
Lloyd "Kiva" New
(1916–2002, Cherokee) for *Kiva*
Dress, 1950s
Screen-printed cotton and metal
Courtesy Fashion by Robert Black
with Doreen Picerne

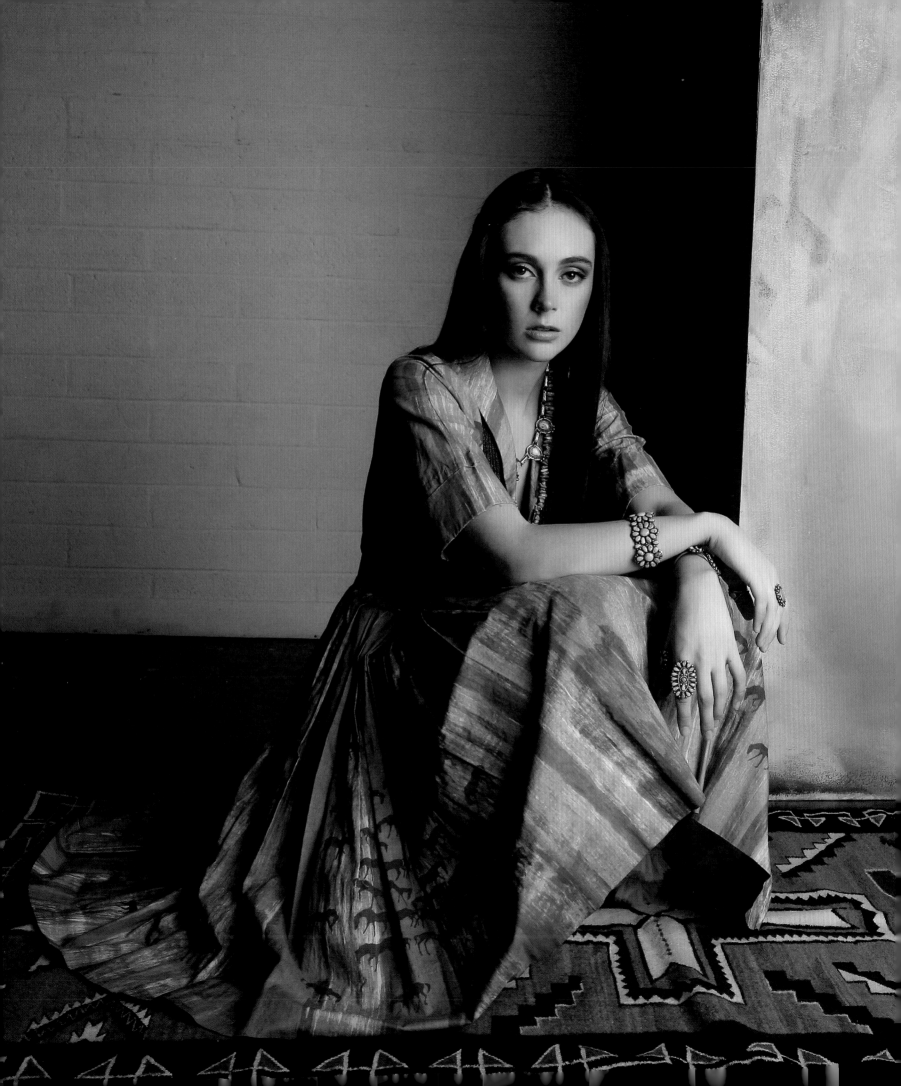

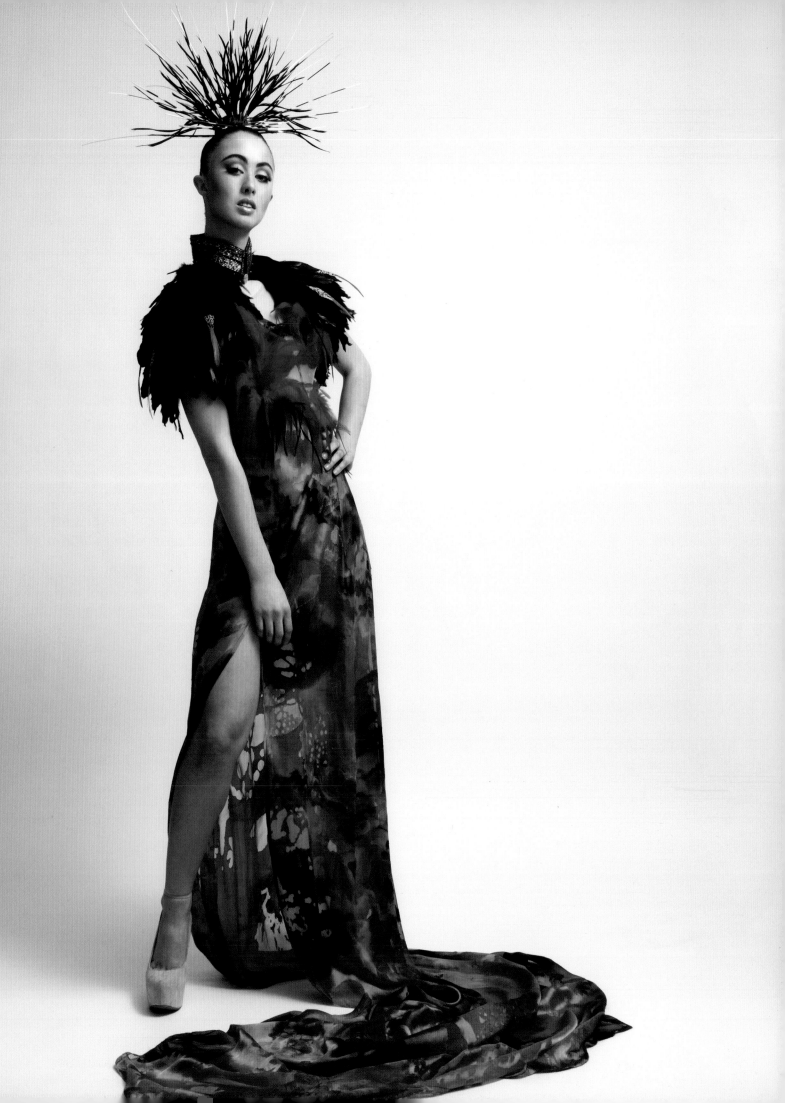

Orlando Dugi

Diné [Navajo]

——

This ensemble has a powerful stage presence. It is designed for the theater of fashion, where spectacle and the mastery of materials are highly prized. There is drama in the volume and fluidity of the dress; the cape provides the puff of pageantry, and the headpiece's quills add a sexy element of danger.

Although the ensemble is provocative, the designer's goal is primarily to elevate clothing to couture. Orlando Dugi's unique take plays with the fantasy of fashion; it also evokes what Dugi calls "Dressing for the Holy Ones," the longstanding Native tradition of honoring ancestors through clothing.

Dugi's deep respect for his heritage can be seen in the interesting combination of vibrant color and soft, watercolor-style pattern; and in the flourishes of texture from the embellishments of feathers, quills and beads. The result is bold yet refined Native imagery filtered through the lens of high fashion glamour. – JC

PLATE 6
Orlando Dugi
(born 1978, Diné [Navajo])
Dress, headpiece, and cape, "Desert Heat"
Collection, 2012
Paint, silk, organza, feathers, beads,
and 24k gold; porcupine quills and feathers;
feathers, beads, and silver
Courtesy the designer

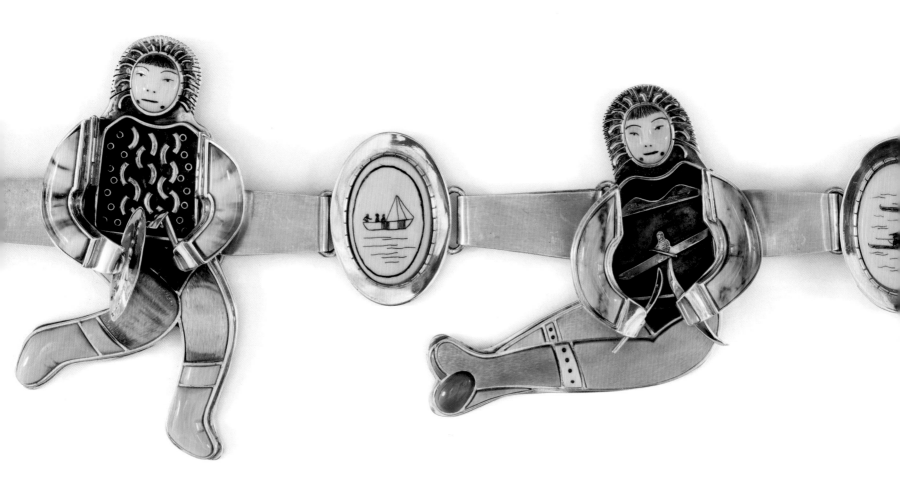

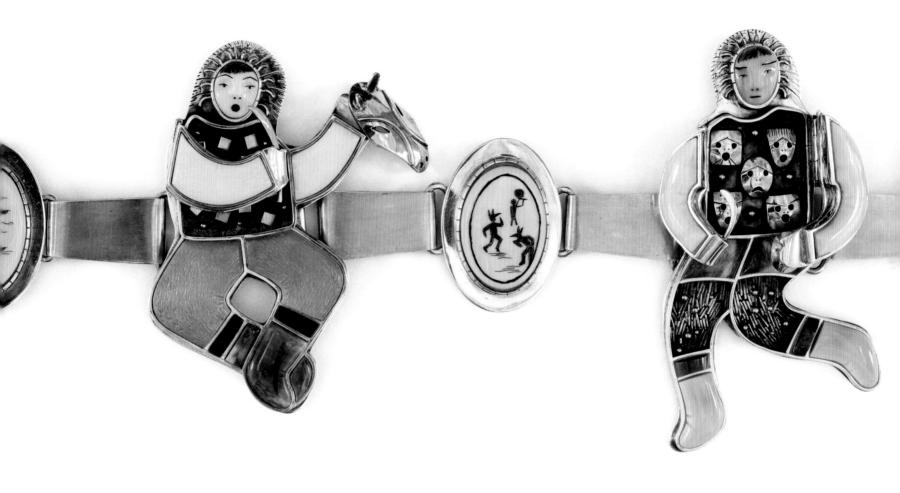

Denise Wallace
Chugach Aleut

—

PLATE 7
Denise Wallace
(born 1957, Chugach Aleut)
Craftspeople Belt, 1992
Sterling silver, 14k gold, fossil ivory, sugilite,
chrysocolla, variscite, chrysoprase,
lapis lazuli, coral, lace agate, and silicated
chrysacolla; Museum of Contemporary
Native Arts, Santa Fe, AT-58

Denise Wallace's accessory work has a sophisticated aesthetic, and her pieces are created with great technical precision. Wallace uses high-quality materials, including precious metals, fossil ivory, coral, lapis lazuli and other semiprecious stones. This combination alone is enough to inspire connoisseurs and collectors.

Beyond commerce, however, Wallace's creations serve a higher purpose—storytelling. Her Aleut heritage shapes her artistic expression. For a growing sector of the fashion industry, message and meaning are as valuable as materials and manpower—and sometimes more so.

Craftspeople Belt is Wallace's tribute to the boat carvers, mask makers, basket weavers, ivory carvers and doll makers of her community. She was inspired to create it after she participated in a Native artist group show at the Anchorage Museum, Alaska.

Objects like these have great cultural and personal significance for Wallace and for her clientele. Her pieces feature people, places, animals, artifacts, masks, and motifs, and explore themes of nature, healing, growth and transformation; they have great authenticity and resonate powerfully with her audience. – JC

Frankie Welch

Cherokee

—

This dress, designed for and worn by First Lady Betty Ford, conveys an aesthetic of power and position. Every sartorial choice the president's wife makes contributes to her public image. For designers to be successful in the political arena, they must be able to strike a balance between the fashion influences of their day and their stylistic legacies. It's clear that Frankie Welch understood the demands of her high-profile clientele, including those of Betty Ford.

Although the dress dates from the era, it does not scream "1970s!" And that's probably a good thing—the decade has a lot to apologize for, fashion-wise. But Welch doesn't. There's a timelessness to this dress's silhouette, color and embellishment that helps its style hold up well even after forty years.

The dress's lines are minimal and modern, and the level of workmanship declares that it's a luxury item. Welch's color choices also send a powerful message. The red silk suggests power and strength, while the delicate gold embroidery evokes success and prestige. The combination was well-chosen for a woman who, in addition to her social duties as First Lady [FIG. 24], in her "spare time" worked on hot-button social issues from gun control to breast cancer to drug and alcohol addiction. -JC

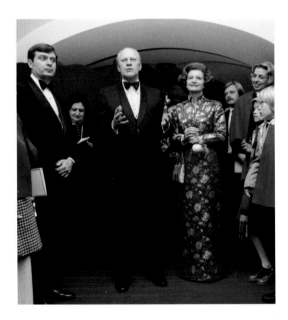

FIG. 24
First Lady Betty Ford wearing dress by
Frankie Welch
at White House Christmas Party,
December 17, 1974

PLATE 8
Frankie Welch
(born 1924, Cherokee)
Dress designed for First Lady Betty Ford, 1974
Embroidered silk
Gerald R. Ford Museum,
Grand Rapids, Michigan, 1983.88.3

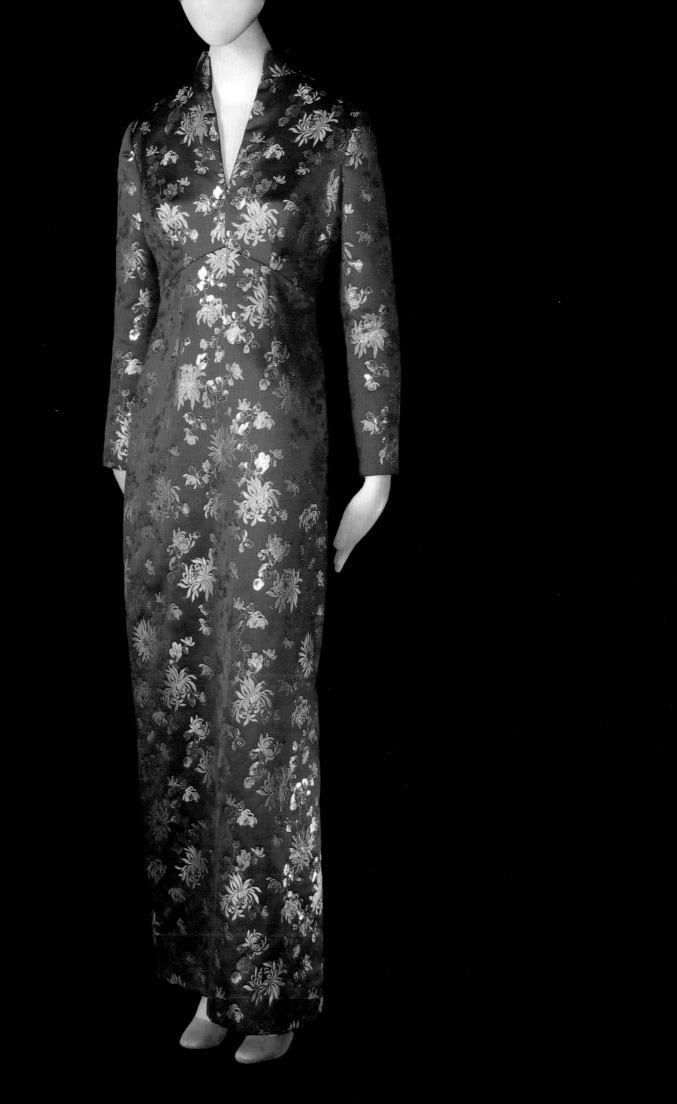

PLATE 9
Maria Samora
(born 1975, Taos Pueblo)
Lily Pad bracelet, 2014
18k gold, palladium white gold,
and diamonds
Courtesy the designer

(right)
PLATE 10
Lloyd "Kiva" New
(1916–2002, Cherokee) for *Kiva*
Dress, about 1960
Screen-printed cotton
Courtesy Fashion by Robert Black
with Doreen Picerne

PLATE 11
Robin Waynee
(born 1971, Saginaw Chippewa)
Convertible necklace, 2014
18k gold, blackened sterling silver,
Tahitian pearl, sphene, diamonds,
and pink sapphires
Courtesy the designer

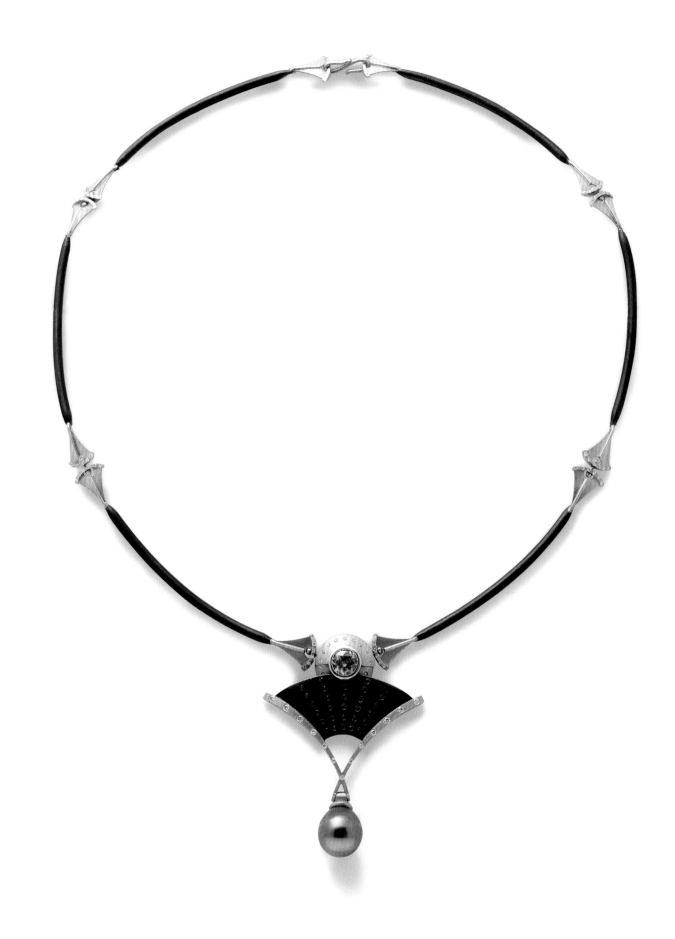

PLATE 13
Virgil Ortiz
(born 1969, Cochiti Pueblo) and

Donna Karan
(born 1948, American) for *Donna Karan*
Skirt, Spring/Summer 2003
Cotton
Courtesy Ellen and Bill Taubman

PLATE 12
Charles Loloma
(1921–1991, Hopi)
Bracelet, about 1975
Ironwood, silver, lapis lazuli, turquoise,
coral, fossil ivory, and abalone shell
Courtesy Leslie Beebe
and Bruce Nussbaum

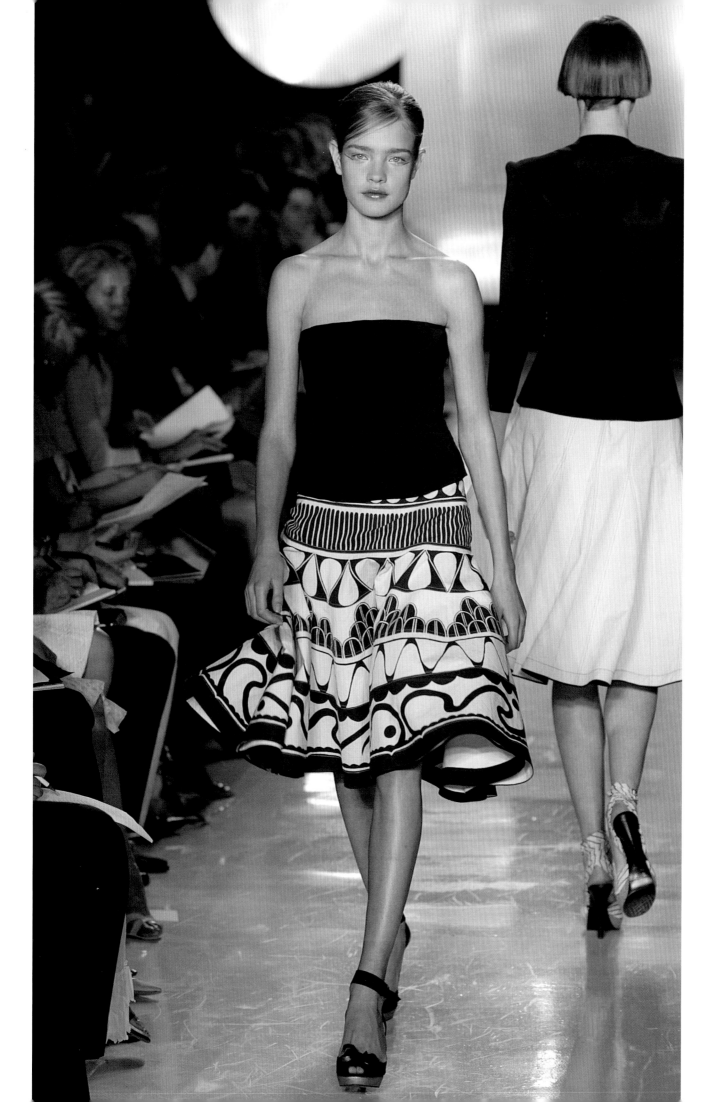

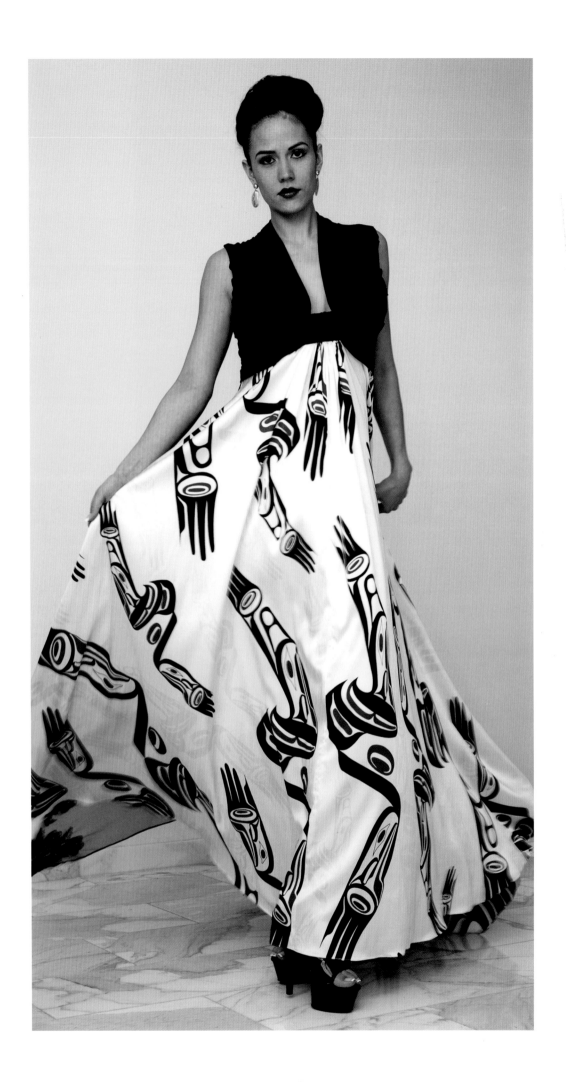

Dorothy Grant
Haida

—

Dorothy Grant's middle name might as well be "Pioneer." As the first Native woman to win an international following for her fashion designs, she paved the way for other Native American designers, and today remains at the top of her fashion field.

For years, she sold her lines of ready-to-wear, formal wear, and couture under separate labels at her Vancouver boutique. In this elegant gown, from her DG Gold Label, the red and black Haida eagle is emblazoned across the full ivory silk skirt. The classic yet deep-cut neckline has sex appeal, enlivening an otherwise conservative full-length dress. Grant was one of the first to design and produce her own fabrics in bulk and to use them in one-of-a-kind or limited-edition garments. – JRM

PLATE 14
Dorothy Grant
(born 1955, Haida) for *DG Gold Label*
Eagle Gala dress, 2013
Silk, tulle, synthetic materials, sequins,
and floral appliqué
Courtesy the designer

PLATE 15
Pat Pruitt
(born 1973, Laguna Pueblo) and
Chris Pruitt
(born 1981, Laguna Pueblo/Chiricahua Apache)
Belt buckle, 2012
Stainless steel, silver, Teflon,
turquoise, and coral
Peabody Essex Museum, Salem, Massachusetts,
Museum purchase with funds
donated by Robert N. Shapiro, 2012.8.1

Wendy Ponca

Osage

—

Dresses made from materials used in the Space Shuttle don't *seem* like typical Native fashion, but Kimberly "Wendy" Ponca's are the real deal. She spent most of her career in Santa Fe, where she taught fashion design at the Institute of American Indian Arts from 1983 to 1993. As a teacher/practitioner, she knows the value of a good production, and puts almost as much effort into her runway shows as she does into the garments themselves.

In Santa Fe in the 1990s, Ponca created a collection of Mylar dresses she called "Ceremonial Attitude for the New Millennium." She still uses the reflective material, which recalls the Sky World, home of the ancestors in Osage creation stories. She also explores other elements of Osage cosmology, notably snakes and eagles. The Osage word for snake, *wah'zha'zhe*, is close to the tribe's own name, and Ponca has sometimes painted serpents onto her models' backs. The striking visual statement declared a connection between the Osage and the snake. She has also put eagle feathers in their hair, as here. They evoke the birds that, according to Osage tradition, lent the tribe wings to fly from Sky World to Earth. In this dress, designed in 2013, Ponca brings ancient symbols to her cool, futuristic silver gown, creating an ultra-modern garment that still honors the Osage worldview. – JRM

PLATE 16
Wendy Ponca
(born 1960, Osage)
Dress, 2013; Mylar, fur,
and feathers
Courtesy the designer

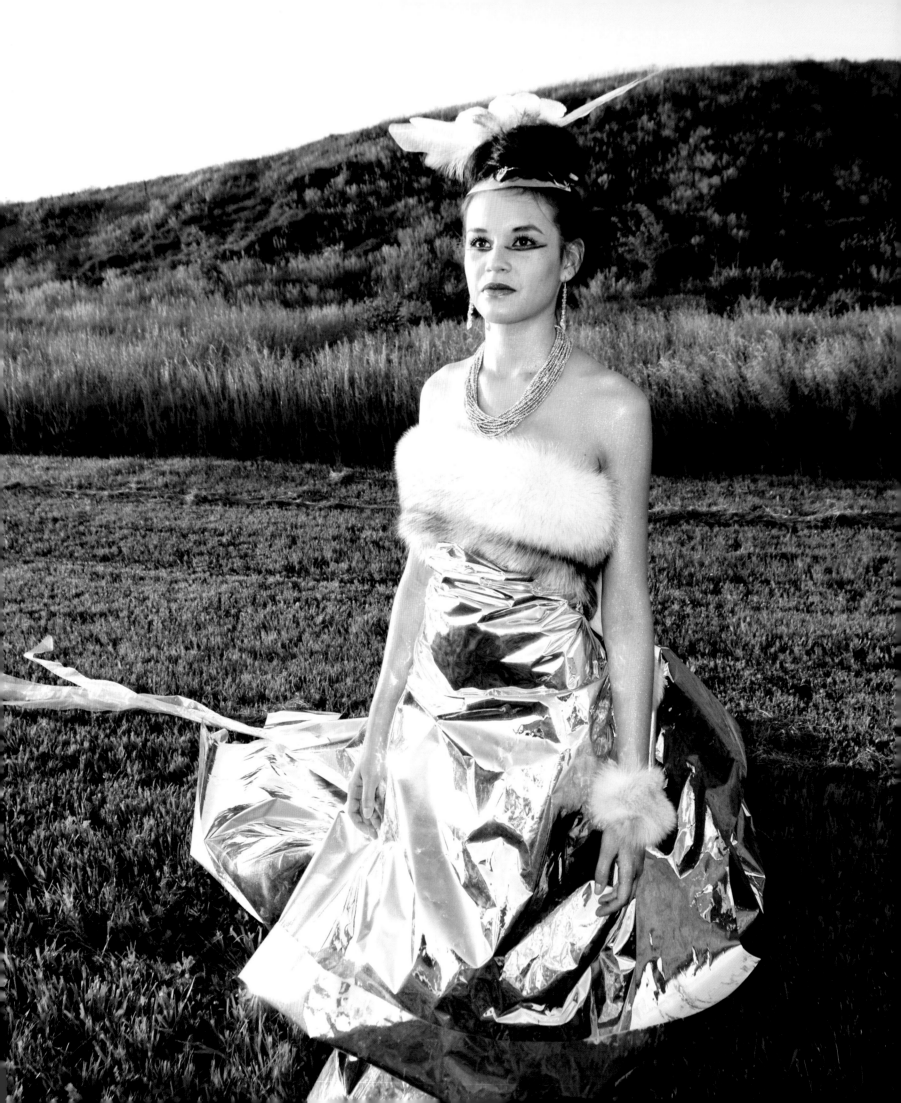

RE-
VISIT-
ORS

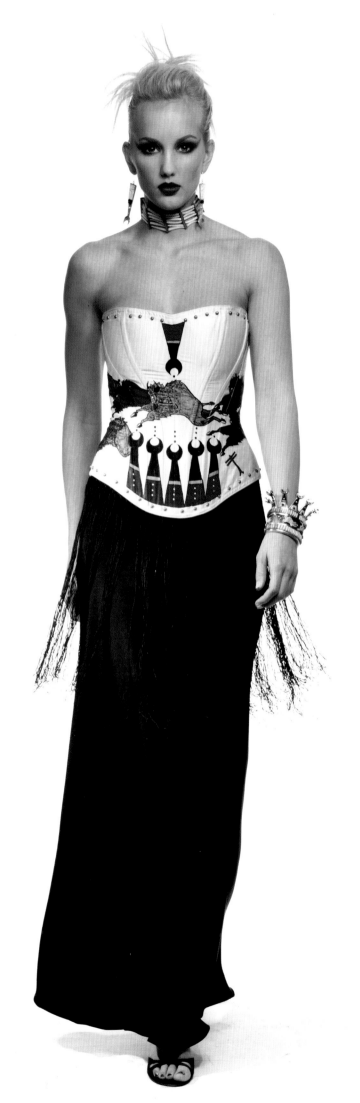

PLATE 17
Dallin Maybee
(born 1974, Northern Arapaho/Seneca) and
Laura Sheppherd
(born 1957, American)

Corset and skirt, 2010
Silk, cotton, and steel; silk crepe and
vintage piano shawl fringe
Courtesy the designers

1794
TREATY OF
CANANDAIGUA

ARTICLE 1
PEACE AND FRIENDSHIP
are hereby firmly established and shall
be perpetual between the United States
and the Six Nations.

ARTICLE 2-3-4
The United States acknowledges the
lands that belong to the Six Nations—
Seneca, Oneida, Mohawk, Onondaga,
Cayuga and Tuscarora, and agree to
never claim or disturb them.

ARTICLE 7
Note: Annual payment of annunity goods
-treaty cloth shall be provided to bind
this Treaty.

Signed in New York Nov 11, 1794
TREATY CLOTH SHIRT

Carla Hemlock
Mohawk

—

It's always fantastic when politics, art and style come together the way they do here. Carla Hemlock's shirt commemorates the 1794 Treaty of Canandaigua, negotiated between the U.S. government and the Iroquois Confederacy. Signed by sachems from the Grand Council of the Six Nations, and by George Washington, the treaty was presented in two versions: a document written in English, and a wampum belt, which encoded the articles in a pattern of purple and white shell beads.

The treaty is still in effect. One of its provisions commits the U.S. government to an annual payment of annuity goods, including "Treaty Cloth," to the Haudenosaunee (Iroquois) people. Each year, the government duly presents the tribe with fabric—now pieces of muslin, not the original (and at the time highly valuable) bolts of calico.

The shirt is made from the 2009 treaty cloth; it displays the treaty's articles in both English and wampum. Although the fabric itself no longer has much inherent value, two centuries of uninterrupted annual presentation give it tremendous symbolic importance. It is a rare and precious example of the U.S. government's commitment to a treaty signed with Native people. – JRM

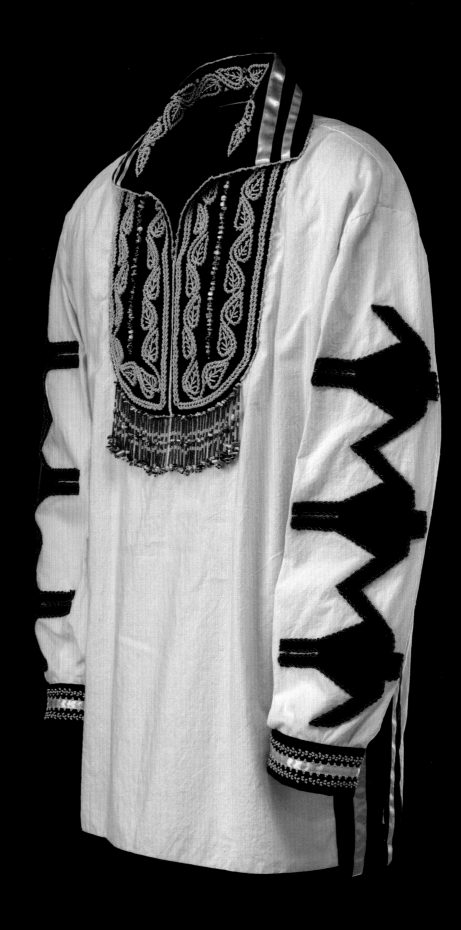

PLATE 18
Carla Hemlock
(born 1961, Mohawk)
Treaty Cloth Shirt, 2012
Cotton treaty cloth, broadcloth appliqué, glass beads, silk, and wampum shell
Smithsonian National Museum of the American Indian, Washington, DC, 269144.000

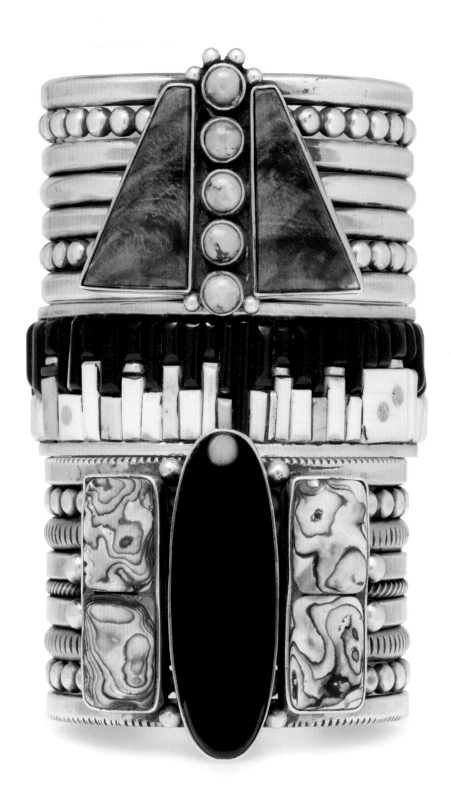

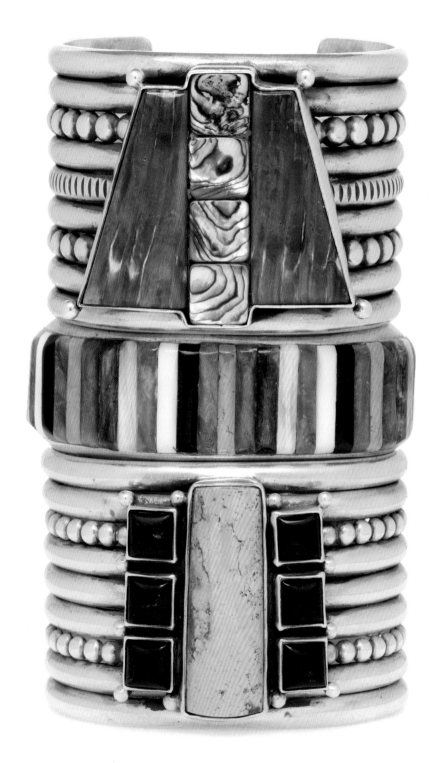

PLATE 19
Mike Bird-Romero
(born 1946, Ohkay Owingeh
[San Juan] Pueblo), and

Eddie Begay
(Diné [Navajo]), left center and

Ray Adakai and **Alice Shay**
(Diné), right center

Bracelets, 2000–10
Sterling silver, spiny oyster, abalone
shell, turquoise, jet, and onyx
Courtesy Catherine B. Wygant

Jamie Okuma

Luiseño/Shoshone-Bannock

—

Jamie Okuma was inspired to embellish these Christian Louboutin boots by her Native heritage but also by her love of fashion. The graphic bird and floral motif, all over beading, and high contrast color reference her cultural background in much the way Louboutin's boots, with their red-lacquered soles, evoke the shoes of 18th-century French aristocrats.

For this work, Okuma bought the beautiful high fashion boots, then completely resurfaced them, covering the mesh uppers in glass beads. Okuma grew up in a culture where everything was beaded, and she enjoys tackling new artistic challenges, so why wouldn't she? Extending her practice into the world of fashion to create a new level of high-end footwear was a natural step (no pun intended) in the evolution of her work.

Okuma creates her beaded objects through painstaking technique and meticulous attention to detail. They rival the work coming out of any couture atelier. Although they are spectacular works of art, they are also utilitarian objects, designed not just to be admired but also to be worn. – JC

PLATE 20
Jamie Okuma
(born 1977, Luiseño/Shoshone-Bannock)
Boots, 2013–14
Glass beads on boots designed
by Christian Louboutin
(born 1964, French)
Peabody Essex Museum, Salem, Massachusetts,
Museum commission with support from
Katrina Carye, John Curuby,
Dan Elias and Karen Keane,
Cynthia Gardner, Merry Glosband, and Steve
and Ellen Hoffman,
2014.44.1AB

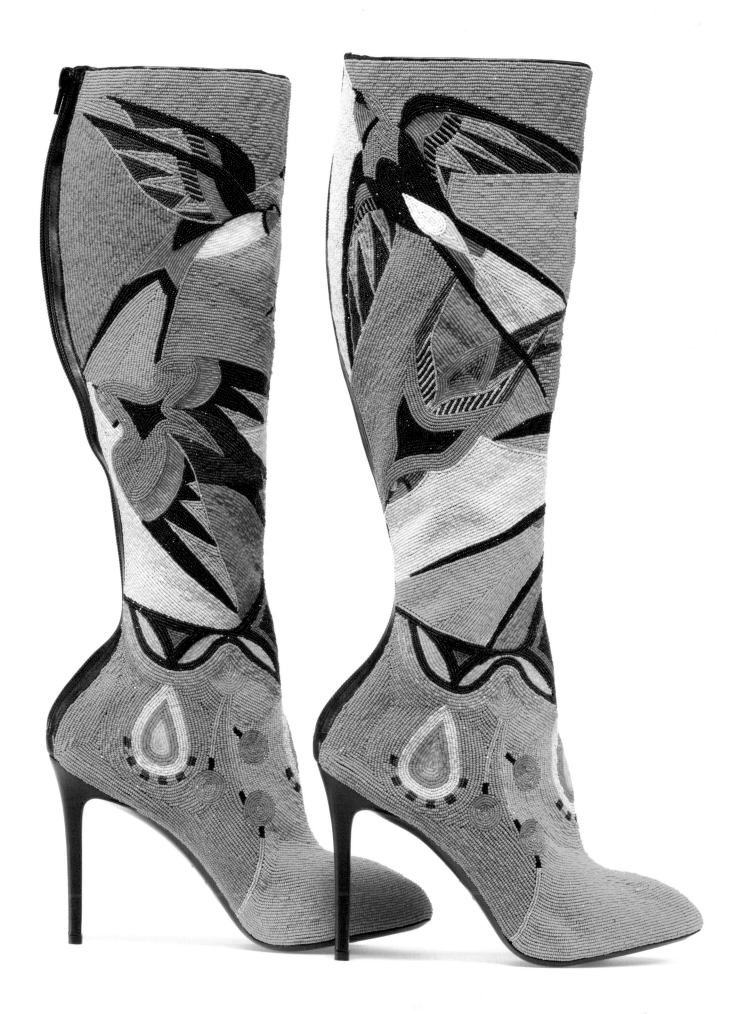

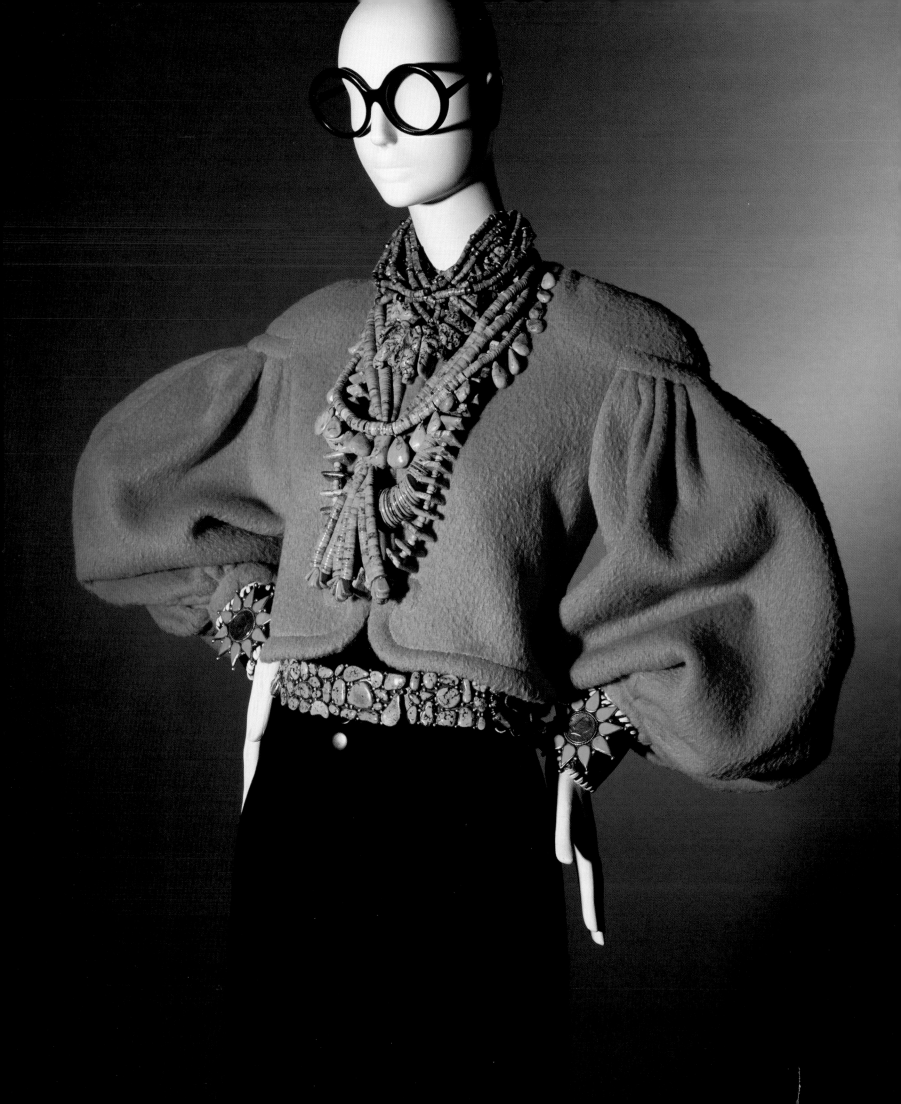

Iris Apfel
American

—

Iris Apfel is an eclectic collector of beautiful things. Although as a style icon she's associated with certain looks—fabulously oversized eyewear comes to mind—nothing is off the table when it comes to adding a new dimension to an ensemble or to her collection as a whole. And while her extensive wardrobe contains many leading fashion labels, her special brand of fashion fusion prioritizes idiosyncratic personal style over industry trends.

You can't say Apfel pushes the boundaries between couture and craft, or art and artifice, because she removes them altogether. This ensemble layers multiple necklaces, pairing them with cuff bracelets and a belt. All are vintage Navajo, in silver and turquoise; they date from the 1920s to the 1950s. The earthy opulence of the Native American jewelry is here set off by the shocking-pink Lanvin haute couture top.

The brilliance of Apfel's mashups comes from her astute choices about how to put together an outfit. No one thing overwhelms the whole. Her curiosity, sense of play, and respect for each piece in an ensemble helps highlight how different it is from the others—but also how surprisingly well it works with them. –JC

PLATE 21
Ensemble styled by **Iris Apfel**
(born 1921, American)
Jacket, trousers, necklaces, cuff bracelets,
and belt, various dates
Wool, Jules-Francois Crahay (1917–1988, Belgian)
for *Lanvin haute couture*, about 1989;
wool broadcloth, about 1990;
silver and turquoise, Pueblo and Diné (Navajo),
1930s–1950s; silver, turquoise, leather,
and Kennedy silver dollars, probably Diné, early
1970s; silver, turquoise, and leather, Diné, 1940s
Iris Apfel collection

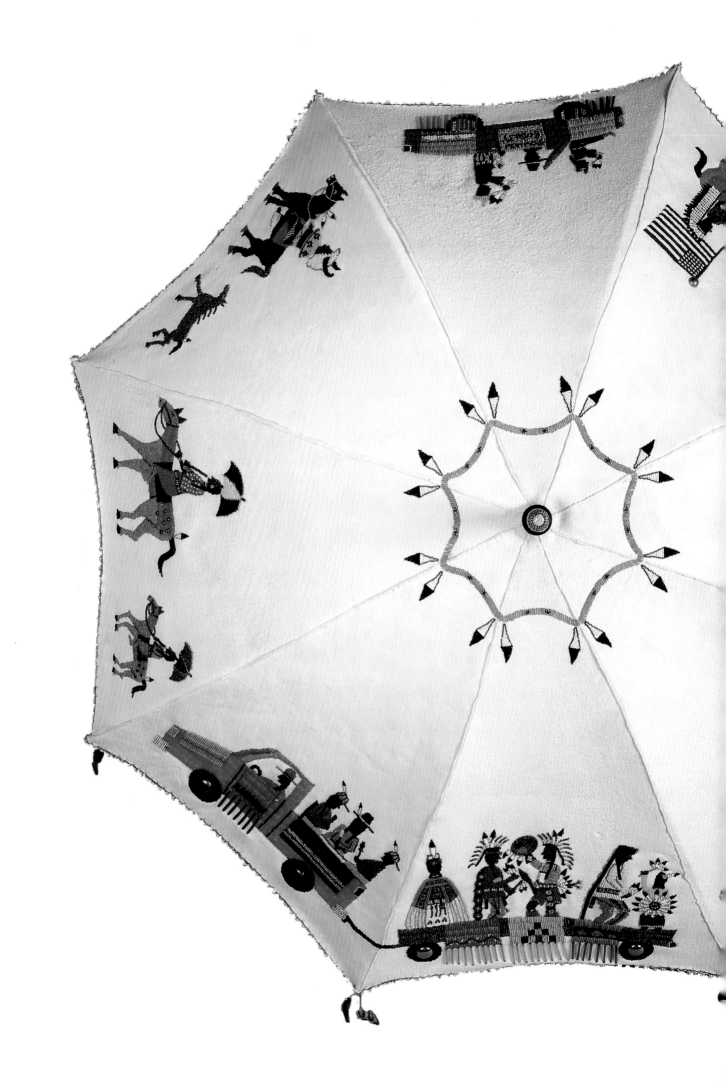

PLATE 22
Teri Greeves
(born 1970, Kiowa)
Indian Parade Umbrella, 1999
Brain tanned deer hide, glass
beads, abalone shell, Bisbee turquoise,
cloth, brass and nickel
studs, Indian bead nickels, and antique
umbrella frame
Courtesy Gilbert Waldman

PLATE 26
Dwayne Wilcox
(born 1957, Oglala Lakota)
Medicine Hat, 2013
Vintage paper and pigments
Courtesy the designer

(right)
PLATE 27
Juanita Lee
(Kewa [Santo Domingo] Pueblo)
Dress and belt, 1970
Commercial fabric and
embroidery thread
Heard Museum, Phoenix, Gift of
Mareen Allen Nichols, 4353 29 a-c

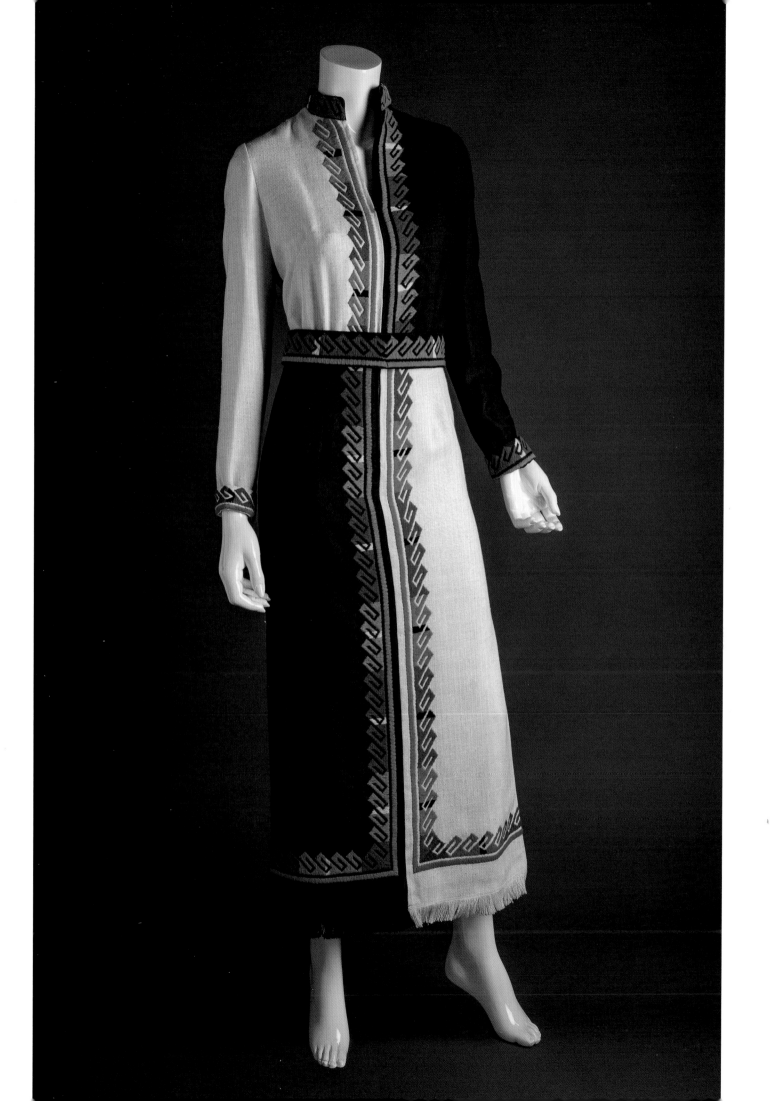

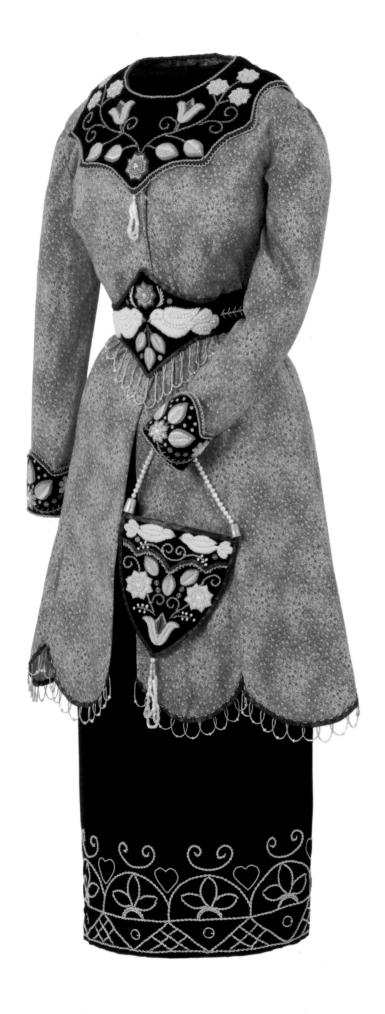

Chloe French
Tlingit

—

Chloe French found the inspiration for her melton wool and bead collar in a picture book illustration of an ancient petroglyph from Alaska's Baranof Island. The work had great resonance for French: she saw in it the primal desire for self-expression that has existed in people across history. Petroglyphs are key to French's work; for her, they have an incredible ability to convey a specific sense of place, but are also beautiful links to another time.

Respecting the border between traditional and contemporary culture is the source of the integrity of French's process. Her minimal modification of classic forms allows ancient imagery to resurface in new objects.

French has a strong sense of her own responsibility to preserve and pass on knowledge. The beaded bib is a garment that has traditionally been used exclusively in tribal ceremonies. French adapted the collar, using authentic appliqué and beadwork techniques and the time-honored colors of Tlingit art, in the hopes of making these Native styles more accessible to a broad audience. — JC

(left and previous spread)
PLATE 28
Niio Perkins
(born 1980, Akwesasne Mohawk)
Emma ensemble, 2010
Cotton, velvet, glass beads, and metal pins
Southwest Museum of the
American Indian Collection,
Autry National Center, Los Angeles
Jackie Autry Purchase Award, American Indian
Arts Marketplace, 2010.62.1–.7

PLATE 29
Chloe French
(born 1945, Tlingit)
Sitka Petroglyph collar, 2013
Beads and wool
University of Alaska Museum
of the North, Fairbanks

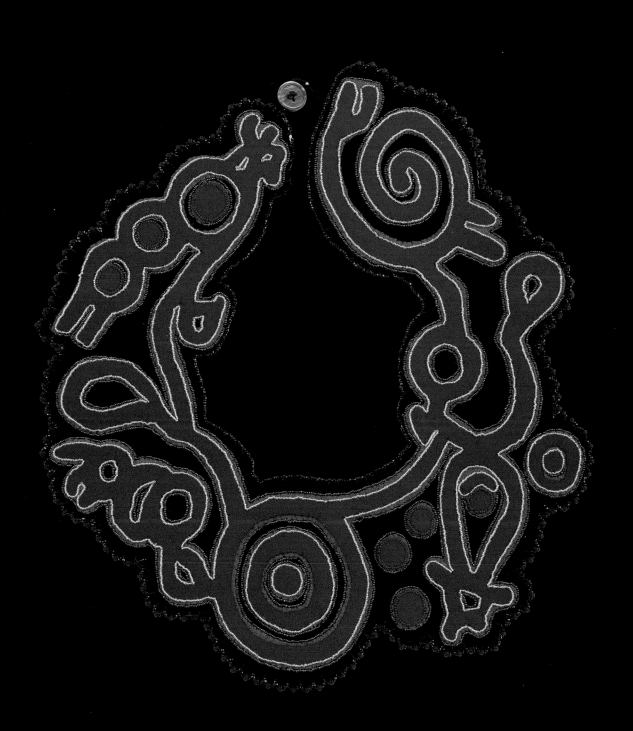

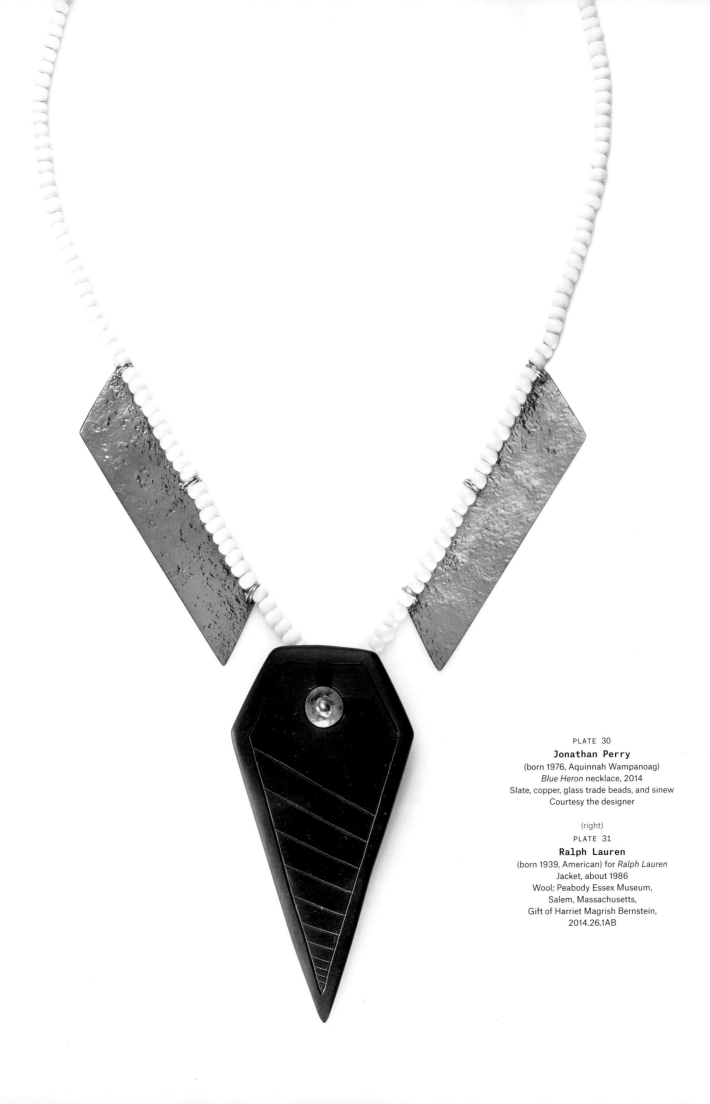

PLATE 30
Jonathan Perry
(born 1976, Aquinnah Wampanoag)
Blue Heron necklace, 2014
Slate, copper, glass trade beads, and sinew
Courtesy the designer

(right)
PLATE 31
Ralph Lauren
(born 1939, American) for *Ralph Lauren*
Jacket, about 1986
Wool; Peabody Essex Museum,
Salem, Massachusetts,
Gift of Harriet Magrish Bernstein,
2014.26.1AB

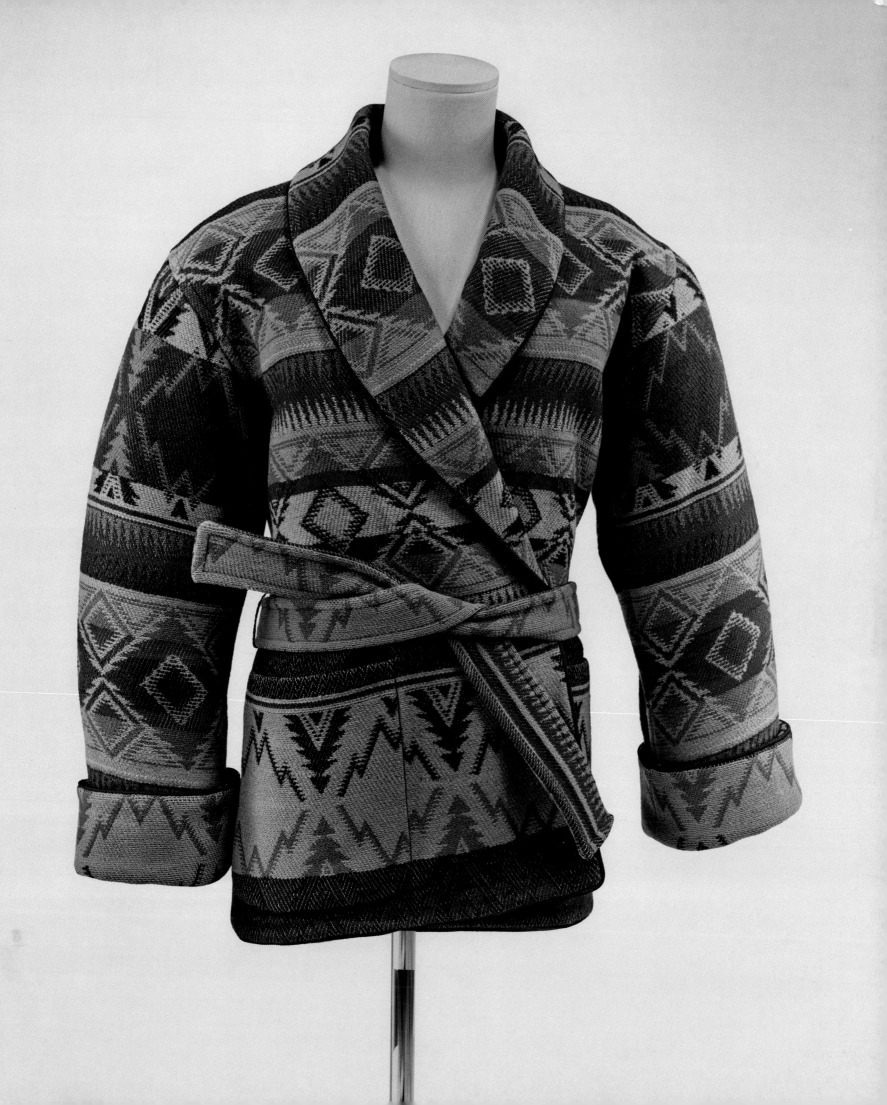

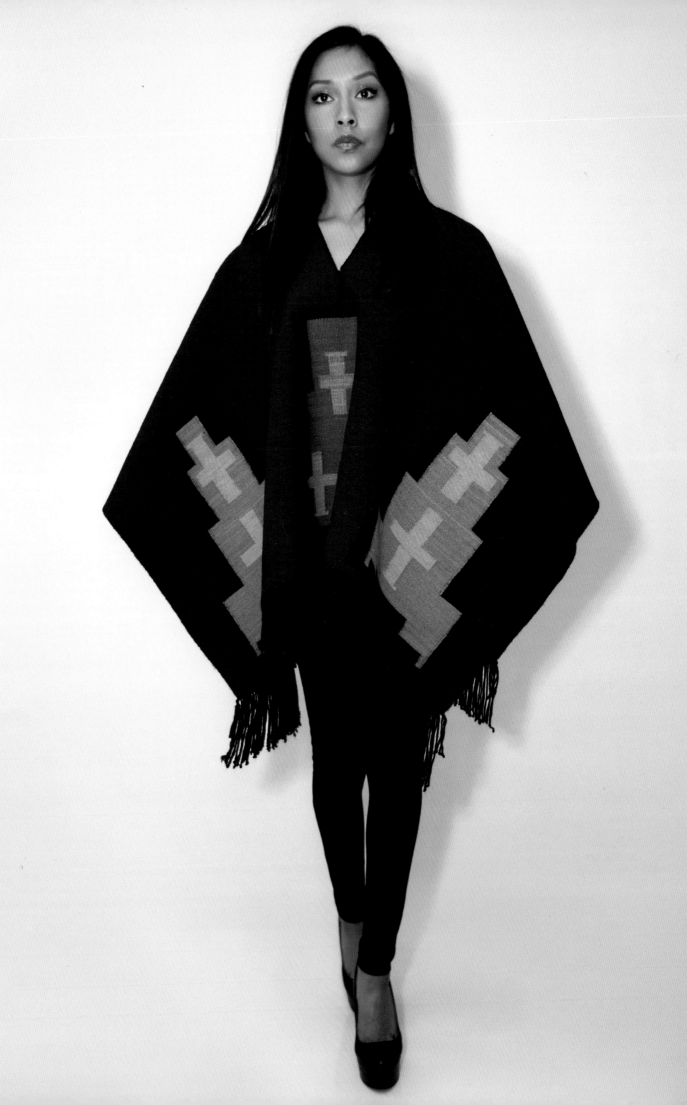

Isaac Mizrahi

American

—

The design origins of Isaac Mizrahi's heavily embroidered, colorful sheath dress can be found in the art of Northwest Coast totem poles. In 1991, Naomi Campbell famously wore this dress on the cover of *Time* magazine, a testament to its cultural power. But although he loves to use Indian motifs, Mizrahi is not a Native designer. So what to think? Is his appropriation of Native culture a problem? Does his work devalue it in some important way?

The arguments for and against borrowing from Native culture are complex, but one thing is clear: it can hurt when outsiders deploy sacred symbols for non-spiritual purposes. In Northwest Coast tribal cultures, totem pole designs do a lot of things. They may chronicle family histories, indicate social status, commemorate special occasions, or depict ancestors or supernatural beings; in short, they are symbols of identity for the families they represent. But while they're greatly valued for the role they play in indigenous Northwest Coast community life, they are not considered sacred per se. Exact reproduction would be an infringement on a community's cultural rights, but using them as design inspiration is not.

Actually, great fashion designers *must* remain open to all sources of inspiration. This garment doesn't misrepresent a particular Native culture, and it doesn't perpetuate negative stereotypes. Instead, Mizrahi's sophisticated dress interprets the formline designs of Northwest Coast tribes [FIG. 13], referencing but not replicating them. It's an homage to Native design, and a new conduit for the style it emulates. −JC

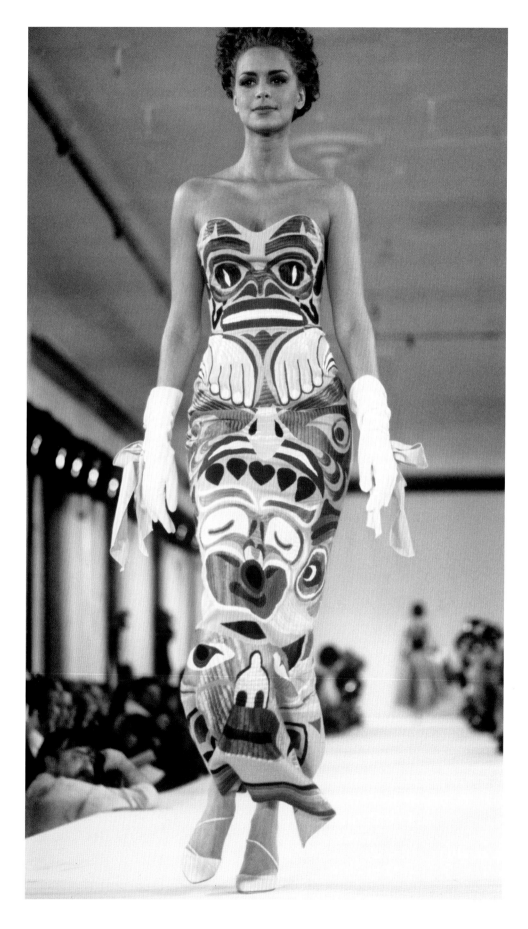

(left)
PLATE 32
D.Y. Begay
(born 1953, Diné [Navajo])
Biníighádzílt̕óní
(*Woven Through*) serape, 2012
Wool and natural dyes
Courtesy the designer

PLATE 33
Isaac Mizrahi
(born 1961, American) for Isaac Mizrahi
Totem Pole dress, Fall 1991
Embroidered flannel
Courtesy the designer

Toni Williams
Northern Arapaho

—

This piece is an inventive fusion of Japanese and Native American design: a kimono with a "ledger art" appliqué. The term describes the drawings Native artists made on lined paper during the late 19th and early 20th centuries. They typically have a flat, linear style and depict scenes of battles and hunting. (The paper came from the discarded ledger books of Indian agents, and replaced buffalo hide as the most common medium for Native drawings.)

The dress's imagery comes from a contemporary work by Sheridan MacKnight, a Chippewa/Lakota artist. It celebrates her daughter; as MacKnight explains, "my painting was inspired and painted for my daughter, Kiana Nikol. She is my first born, blessed with an amazing heritage of beautiful souls, and she is Japanese, Lakota, Chippewa and Scottish." This dress, with its Japanese form and Native pattern, is a physical embodiment of the cross-cultural world that Native Americans inhabit today. It took first prize in the 2011 Santa Fe Indian Market clothing contest, one of whose judges was the American fashion star Tom Ford. –JRM

PLATE 34
Toni Williams
(born 1953, Northern Arapaho)
Kimono, 2011
Silk with ledger art appliqué
Private collection

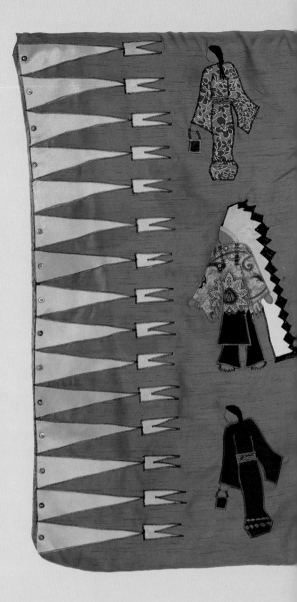

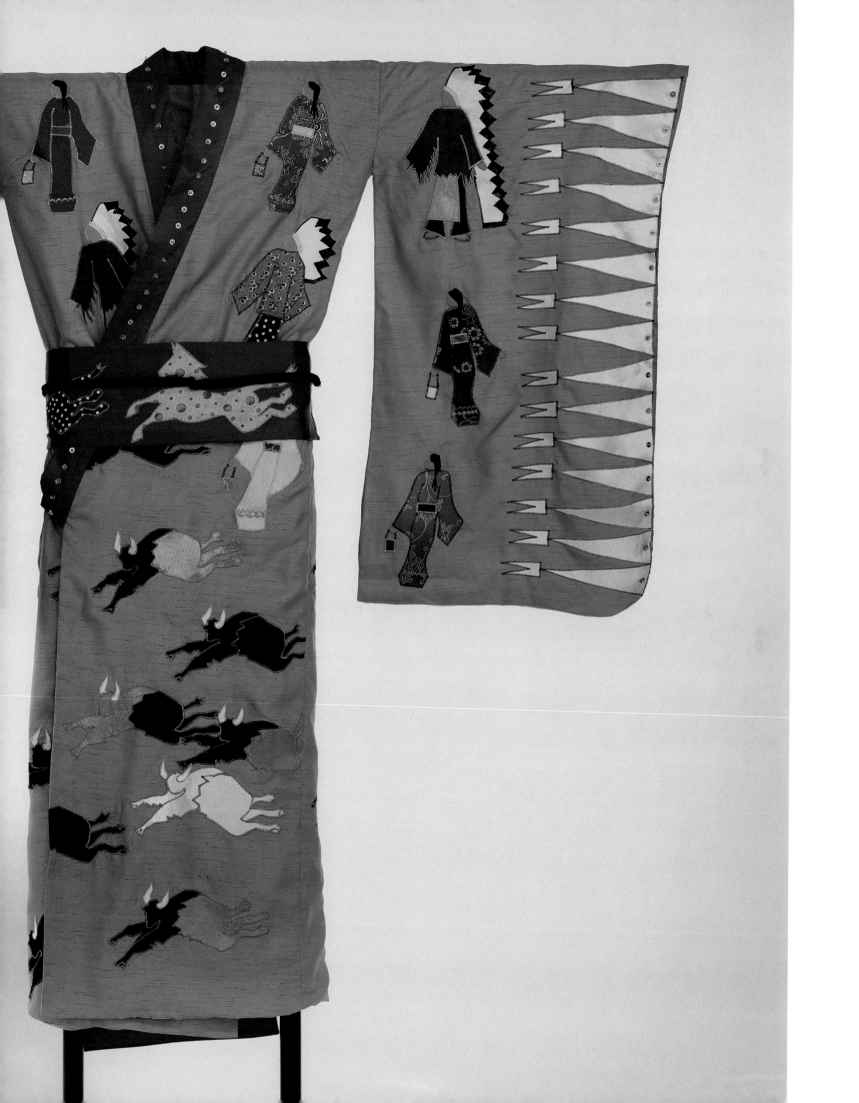

Margaret Wood
Diné [Navajo]/Seminole

—

The revolutionary nature of this simple dress may not be apparent upon first inspection. It is an elongated and tailored version of a *biil*, a traditional woven Navajo women's garment. *Biil* dresses were made from two identical panels, usually woven side by side, that were then sewn together, with openings left for neck and arms. Their color palette usually included cochineal red, indigo blue and aniline black. By the 19th century, fuller velveteen skirts and blouses had replaced the *biil* as the most popular ceremonial dress for Navajo women; after 1900 it was rarely seen. In her 1981 book, *Native American Fashion*, Margaret Wood took a bold step by reclaiming the *biil* and updating it to make it more chic and relevant. Her reworking expressed her pride in a matriarchal legacy of weaving, and today we see more young Navajo women wearing this kind of dress for graduations and other important life events. —JRM

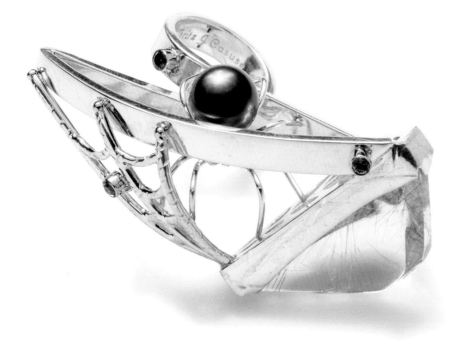

(left)
PLATE 35
Fritz J. Casuse
(born 1968, Diné [Navajo])
Crystal Gazer ring, 2011
Sterling silver, quartz, pearl, and gold
Peabody Essex Museum,
Salem, Massachusetts,
Gift of Ellen G. and Stephen G. Hoffman,
2012.34.1

PLATE 36
Margaret Wood
(born 1950, Diné [Navajo]/Seminole)
Biil (blanket dress), 1980s
Wool; Heard Museum, Phoenix,
Gift of Mr. Tom Galbraith and
Ms. Margaret Wood, NA-SW-NA-C-82

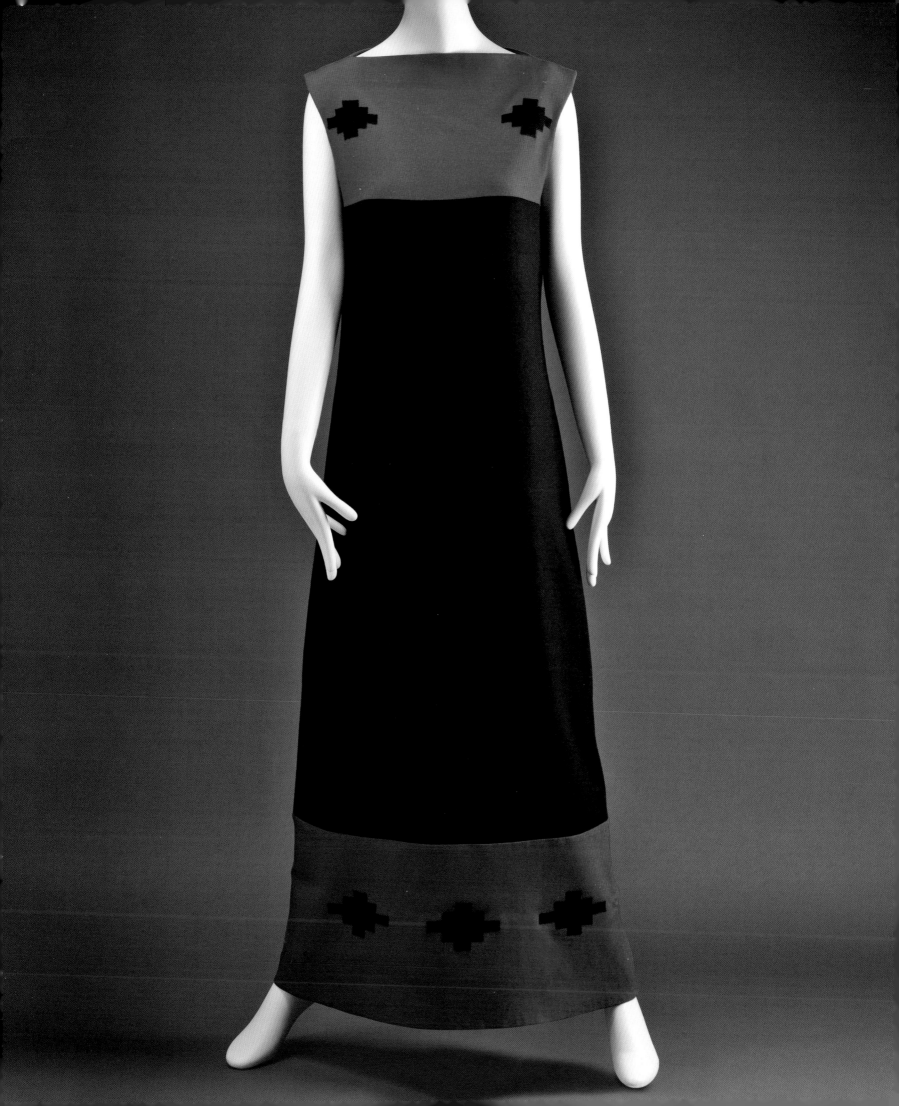

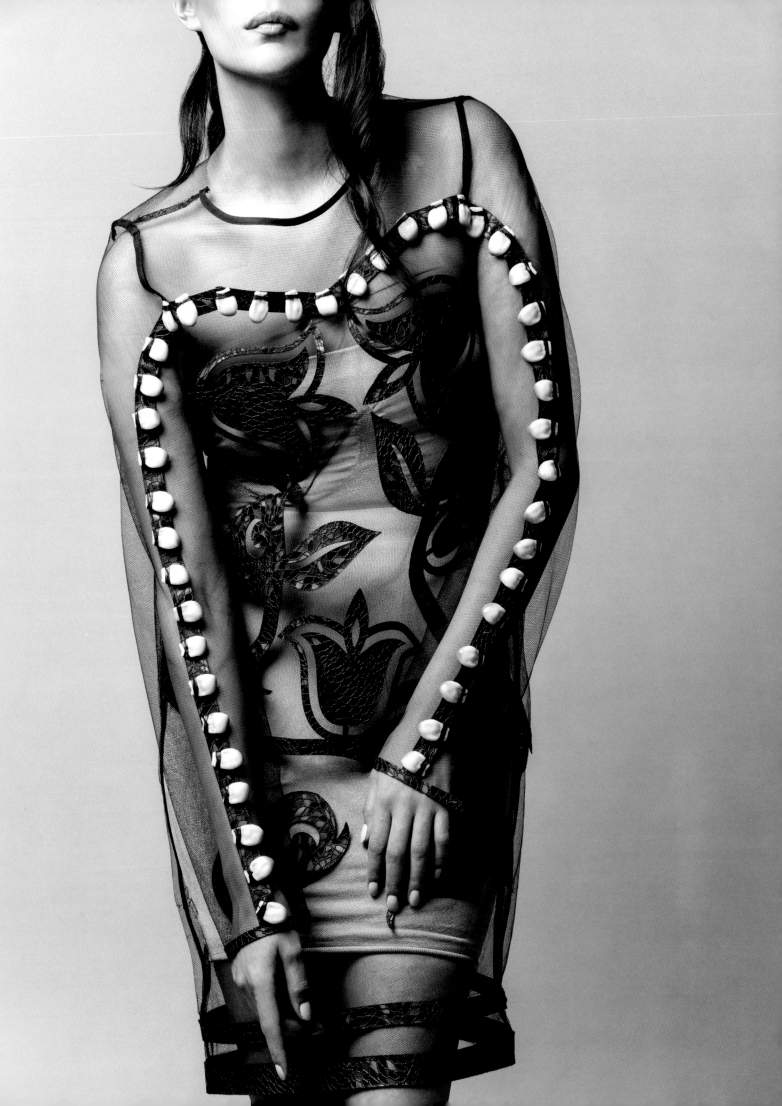

(left)
PLATE 37
Bethany Yellowtail
(born 1988, Apsáalooke [Crow]/Northern
Cheyenne) for *B.Yellowtail*
Old Time Floral Elk Tooth dress,
"Apsáalooke" Collection, 2014
Lace, appliqué, and elk teeth
Peabody Essex Museum, Salem,
Massachusetts, Museum purchase,
2015.22.1

PLATE 38
Caroline Blechert
(born 1987, Inuit)
Cuff, 2014
Porcupine quills, delica beads,
caribou hide, and antler
Peabody Essex Museum, Salem,
Massachusetts, Museum purchase,
2014.52.1

Caroline Blechert
Inuit

—

Arctic winters are long and dark, and the tundra's covered with snow for eight months at a time. In summertime, though, life springs into action, and the landscape blooms in divine hues of purple, green, and rust. The elements in this cuff reference these summer colors: chartreuse-dyed and natural porcupine quills, outlined in perfect delica beads in green, turquoise, rust, black, white and gold. Although quillwork is a traditional Inuit art form, which predates the tribe's first contact with Europeans, beads are a Western technology, one that Inuit artists eagerly embraced from its first introduction.

Blechert uses these components along with others like caribou hide and antlers in her enchanting jewelry. She honors the porcupine, highlighting its natural color gradations, from ivory to rich chocolate black, but also dyeing the quills into brilliant shades. Inuit artists often interspersed rare blue Chinese glass trade beads with treasured natural materials like bear claws, caribou teeth and dentalium shell; Blechert's wrap-around bracelet partakes of this long tradition. –JRM

ACTI-VAT-ORS

Virgil Ortiz
(born 1969, Cochiti Pueblo)
Designer Virgil Ortiz
holding scarf, 2013

Virgil Ortiz
Cochiti Pueblo

—

Virgil Ortiz has been a pathbreaker since before he designed the first pieces for his fashion boutique, HEAT, in 2002. Born into a family of potters, he spent his childhood making pots as well as *Munos*, clay figures depicting circus performers, missionaries, tourists—all kinds of outsiders to the Cochiti Pueblo community, which produced these humorous objects beginning in the 19th century. In his pottery, Ortiz preserves the bold, graphic qualities of historical Cochiti ceramics but adds a sexy, provocative edge that's his alone.

Ortiz' pleasure in creating these figures found expression in fabric as he moved on to fashion. He worked in materials like black leather and vinyl, often using the black and creamy white color palette of ancient Cochiti pottery in his fashion designs. All his work, he says, is inspired by Cochiti traditional stories, and he draws his graphically bold patterns from a Cochiti iconography of snake, wild spinach, water, and other important Pueblo symbols. Ortiz' fashion line features hard-edged looks in leather jackets, bold luxury handbags and silk scarves.

This scarf depicts Kootz, one of the characters in *Evolution*, a full-length film Ortiz is writing. This futuristic reimagining of the 1680 Pueblo Revolt will feature clay figures; costumes will be designed by the artist. Ortiz' mission is simple: to engage Cochiti youth in their own culture, its language, artistic practices and history. Working in multiple mediums, including pottery, film and fashion, is one way he hopes to accomplish this. "What I want to do," he explained, "is to continue the link, to pass it on to the next generation and keep it alive." –JRM

PLATE 39
Virgil Ortiz
(born 1969, Cochiti Pueblo) for *VO*
Scarf, "Indigene" Collection, 2013
Silk
Courtesy Madeleine M. Kropa

Jared Yazzie

Diné [Navajo]

The slogan Jared Yazzie splashed on this T-shirt, "Native Americans Discovered Columbus," expresses his bold vision, and showcases his belief that the humble tee can simultaneously make a fashion and a political statement. Yazzie gives voice to Native consciousness and challenges us to think about things in a new way.

The graphic tee as fashion statement started in the 1970s, when these cheap garments were conceived as innovative marketing devices that gave advertisers a new way to promote their products. It soon became clear that consumers liked using clothes to declare allegiance to their favorite brands. The idea was extended to non-commercial statements of values and identity, and we were off to the races. Ever since, T-shirts have been critical vectors for both self-expression and political protest.

Yazzie is one of those few designers who succeeds at combining mass fashion and political commitment. He fights the commodification of Native styles and values with original imagery and authentic language. –JC

PLATE 40
Jared Yazzie
(born 1989, Diné [Navajo]) for *OxDx*
*Native Americans
Discovered Columbus* T-shirt, 2012
Cotton
Peabody Essex Museum, Salem, Massachusetts,
Gift of Karen Kramer,
2015.11.4

(right)
PLATE 41
MaRia A. Bird
(born 1982, Diné [Navajo]/Hopi/Santa Clara
Pueblo) for *Mea B'fly Designs*
American Horse earrings, 2013
Graphic adhered to balsa wood
Courtesy Karen Kramer

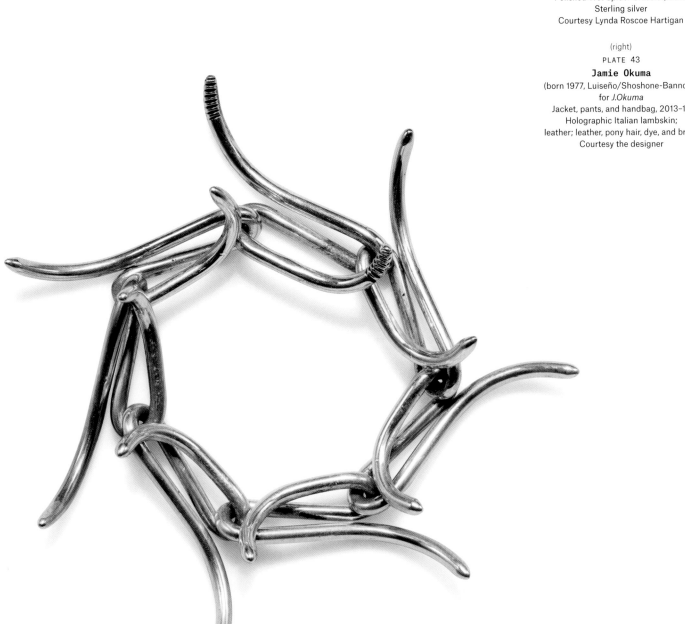

PLATE 42
Cody Sanderson
(born 1964, Diné [Navajo]/Hopi/
Tohono O'odham/Nambé Pueblo)
Polished Wet Spider bracelet, 2013
Sterling silver
Courtesy Lynda Roscoe Hartigan

(right)
PLATE 43
Jamie Okuma
(born 1977, Luiseño/Shoshone-Bannock)
for *J.Okuma*
Jacket, pants, and handbag, 2013–14
Holographic Italian lambskin;
leather; leather, pony hair, dye, and brass
Courtesy the designer

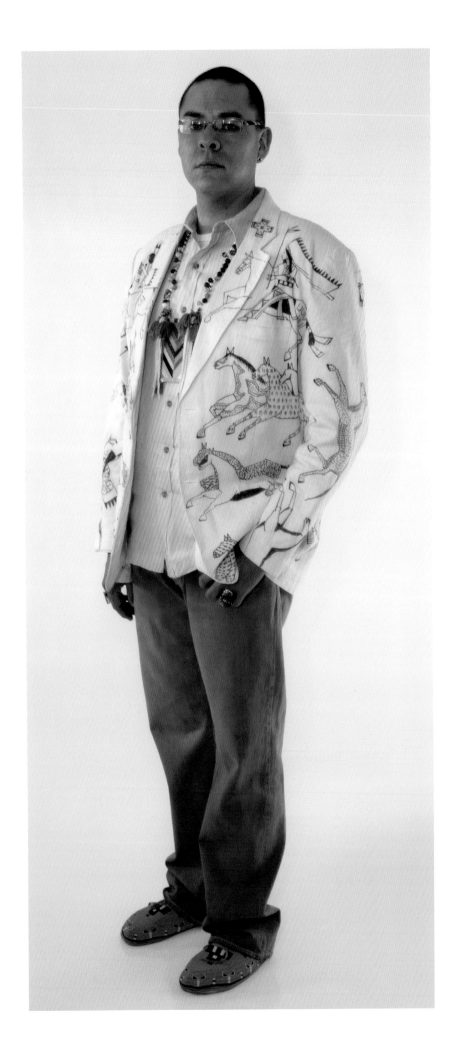

PLATE 44
Ensemble styled by
Kenneth Williams Jr.
(born 1983, Arapaho/Seneca)
Blazer, pendant, moccasins, shirt, and
pants, various dates
Linen with painted ledger designs,
Thomas Haukaas (born 1950,
Sicangu Lakota), 2013; glass beads, wool
broadcloth, brass, wool, yarn, and
brain tanned hide, Kenneth Williams Jr., 2013;
glass beads and leather,
Agnes Spoonhunter Logan (born 1951, Northern
Arapaho), late 1990s; dyed cotton
Courtesy Kenneth Williams Jr. and
Myra Jennings

(right)
PLATE 45
Winifred Nungak
(born 1987, Inuit)
Short coat, 2015
Cotton, Thinsulate, and fox fur
Courtesy the designer

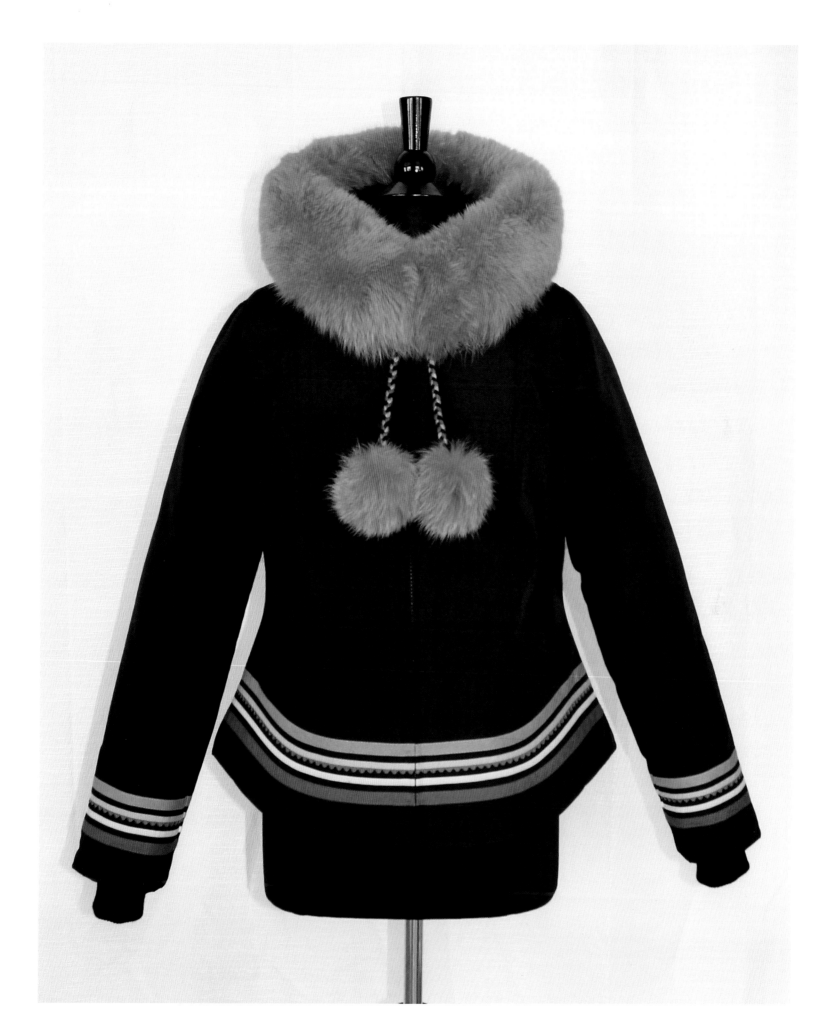

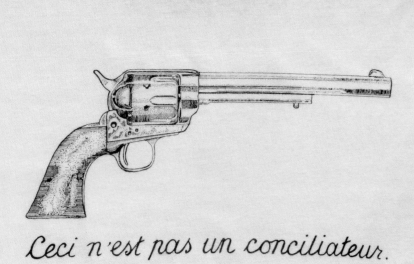

Ceci n'est pas un conciliateur.

Ceci n'est pas un conciliateur.
"THIS IS NOT A PEACEMAKER"
THE "NEW MODEL ARMY METALLIC CARTRIDGE REVOLVING PISTOL"
WAS ADOPTED AS THE STANDARD MILITARY SERVICE REVOLVER FROM
1873-1892. NICKNAMED "THE PEACEMAKER", SAMUEL COLT'S
REVOLUTIONARY SIDE ARM WAS USED BY COLONEL GEORGE ARMSTRONG
CUSTER'S 7TH CAVALRY DURING THE GREAT SIOUX WAR OF 1876.
ON JUNE 25TH, CUSTER AND 267 OF HIS MEN WERE KILLED
WHEN THEY ENGAGED A COMBINED FORCE OF LAKOTA, NORTHERN
CHEYENNE, AND ARAPAHO WARRIORS DESPERATE TO PROTECT
THEIR FAMILIES CAMPED ALONGSIDE THE LITTLE BIGHORN RIVER.
LED BY THE LIKES OF CRAZY HORSE AND CHIEF GALL,
THESE SOVEREIGN ORIGINAL LAND OWNERS UNDERSTOOD THAT
THE IMPLEMENT ON CUSTER'S HIP MEANT ANYTHING BUT PEACE.
RESIST THE HYPE.

Ceci n'est pas un conciliateur.

"THIS IS NOT A PEACEMAKER"

The "New Model Army Metallic Cartridge Revolving Pistol" was adopted as the standard military service revolver from 1873-1892. Nicknamed "The Peacemaker", Samuel Colt's revolutionary side arm was used by Colonel George Armstrong Custer's 7th Cavalry during The Great Sioux War of 1876. On June 25th, Custer and 267 of his men were killed when they engaged a combined force of Lakota, Northern Cheyenne, and Arapaho warriors desperate to protect their families camped alongside the Little Bighorn River. Led by the likes of Crazy Horse and Chief Gall, these sovereign original land owners understood that the implement on Custer's hip meant anything but peace. **RESIST THE HYPE.**

Alano Edzerza

Tahltan

—

Alano Edzerza works in many media, from silverwork jewelry to painting to fashion. Based in Vancouver, he uses the formline style of Northwest Coast indigenous art in his work. Its design building blocks are ovoids and U-forms; here they are used in a bold and striking pattern that covers the whole dress. This hip tunic dress in stark black and white can be worn with leggings or with boots and a jacket. It shares a sporty vibe with the uniforms Edzerza designed for the Netherlands' Winter Olympics team in 2010. Fortunately, you don't have to be an Olympian to wear his streetwear, which includes tunics like this, T-shirts, hoodies and more. —JRM

DETAIL FROM PLATE 48
Alano Edzerza
Chilkat tunic, 2013

(left)
PLATE 47
Nicholas Galanin
(born 1979, Tlingit/Aleut)
*With My Feet I Walk This Land
(and polar bear lost the ice)* shoes, 2015
Leather and polar bear fur
Courtesy the designer

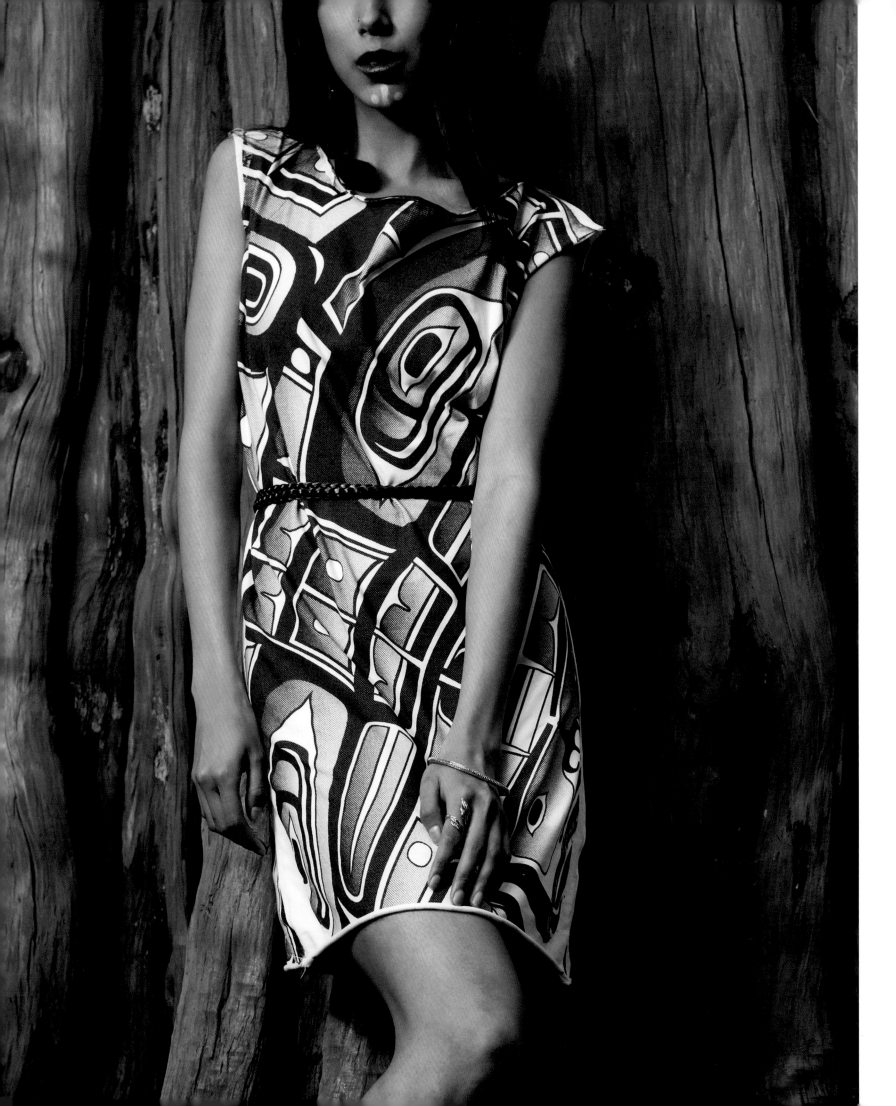

Maya Stewart
Chickasaw/Creek/Choctaw

—

Maya Stewart's designs made a big splash a couple of years ago at Mercedes-Benz Fashion Week. Since then, they've been featured in premier fashion magazines like *Vogue* and *W*, and have been seen on the arms of celebrities about town.

Stewart comes from a family of fashion designers who were rocking the Oklahoma Native fashion scene in the 1970s and '80s. She began designing with her mother, Jimmie Carole Fife, at an early age, but soon launched her own line of handbags, from which this *Carmen* clutch is drawn. Since then, she has designed for luxury handbag luminaries Judith Leiber and Jill Milan.

In 2010, she told the newspaper *The Oklahoman*, "My design objective is to resist the ordinary and ignore the conventional path to creativity."

Designs like this sleek black purse harmonize the ancient and the contemporary. The construction makes use of Native styles from basket weave to Seminole patchwork; its forms derive from Native astronomy and highlight the importance of the Sky World. As Stewart says, "I find inspiration in the history of the Southeastern tribes, and draw on the artistic nature of my American Indian heritage. My theme is to focus on the geometric shapes constant throughout these tribes." –JRM

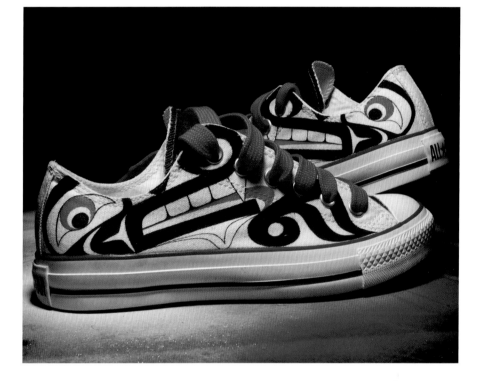

PLATE 50
Jolene Nenibah Yazzie
(born 1978, Diné [Navajo]) for *516 ARTS*
Warrior Women T-shirt, 2012
Cotton
Courtesy M. McGeough

PLATE 51
Louie Gong
(born 1974, Nooksack/Squamish)
Spirit Wolf Chucks, 2010
Fabric dye and acrylic on
Converse sneakers
Courtesy the designer

PLATE 52
Dylan Poblano
(born 1974, Zuni Pueblo)
Knuckle ring, 1999
Silver and gemstones
Museum of Arts and Design,
New York, Gift of Natalie and
Greg Fitz-Gerald,
2008, 2008.42.3

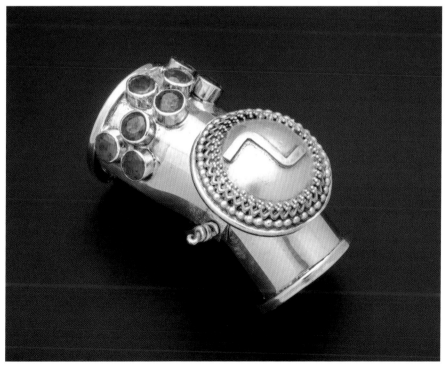

Marcus Amerman
Choctaw

—

Marcus Amerman is an inventive designer who has created a new genre of Native beadwork. His (mostly) representational work often features comic book-style portraits: bold, colorful mashups of historical and pop cultural references. This cuff addresses classic Western stereotypes with style and wit, depicting the Lone Ranger and Tonto, heroes of the popular radio and TV Western serials.

Amerman's interest in social commentary can be found in his work in other media as well, from glass to painting to performance to clothing design. All of it tells us to "mind the gap"; to consider the distance and the overlap between mainstream and Native culture in America. But it also shows the amazing things that can happen when cultures collide.

Fashion designers are always recycling concepts from a past they haven't experienced themselves. The trick to doing this well is to make an idea significant again. Amerman's work reinterprets Native themes, reclaiming styles and ideas that had been appropriated by non-Natives. His goal is to dismantle the misunderstandings and cultural myths that have grown up around his Native heritage. –JC

(left)
PLATE 53
Jeremy Arviso
(born 1978, Diné [Navajo]/Hopi/
Pima/Tohono O'odham) for
Noble Savage; *Definition* T-shirt, 2012
Cotton
Courtesy Jeremy Donovan
Arviso–Noble Savage, LLC

PLATE 54
Marcus Amerman
(born 1959, Choctaw)
Untitled (Lone Ranger and Tonto bracelet), 2004
Glass beads, leather, thread,
rubberized cotton, and brass
Museum of Arts and Design, New York, Museum
purchase with funds provided by the
Horace W. Goldsmith Foundation, 2004, 2004.27

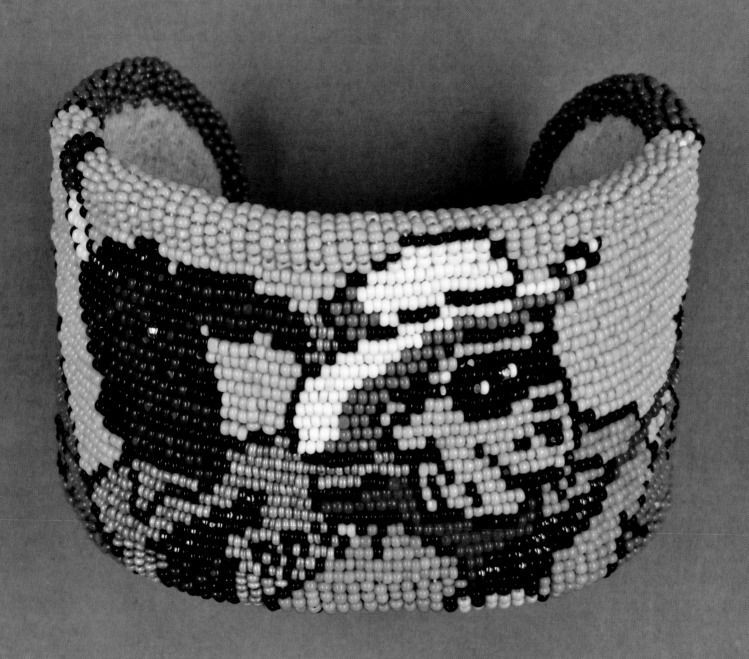

Rico Lanaat' Worl
Tlingit/Athabascan

—

Rico Worl's design sensibility is shaped by the formline style, and he applies it beautifully to the products he makes for a new generation of consumers. His skateboard decks are vehicles for the bold, graphic, yet fluid designs of the indigenous artists of the Pacific Northwest. Although fashioned from new materials, these skateboard decks seem almost as if they could be pieces of 19th-century Tlingit artwork, so closely connected is their style to the region's history and heritage. In fact, Worl's boards are inspired by the pattern boards Tlingit weavers use to make their textiles. His creative process unites his passion for innovation and renewal to his tribe's powerful artistic legacy.

Worl is dedicated to developing new markets for Native art, and to creating new opportunities for its creators. Like many of his contemporaries, he's also interested in the relationship between a work of art and a commodity. He enjoys the fact that his pieces can be used differently depending on the purchaser: a piece could be hung as art on a gallery wall, but in the hands of a different buyer, it could be a functional object, a well-worn, useful part of everyday life. – JC

PLATE 55
Rico Lanaat' Worl
(born 1984, Tlingit/Athabascan)
for *Trickster Company*
Raven and *Eagle* skateboard decks, 2014
Wood and paint
Peabody Essex Museum, Salem, Massachusetts,
Museum purchase, 2014.53.1-2

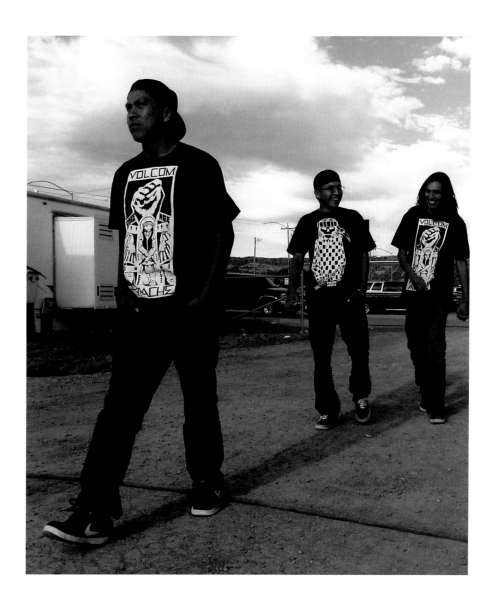

Douglas Miles Designs
San Carlos Apache/Akimel O'odham

PLATE 56
Douglas Miles Designs
(born 1963, San Carlos Apache/Akimel
O'odham) for *Apache Skateboards* and
Volcom Stone-Age
T-shirt, pants, and hat, Fall 2010
Cotton
Courtesy the designer

It was years ago now that Douglas Miles painted his first skateboard for his son. His brand, Apache Skateboards, grew from that first deck, and soon included a line of streetwear. It's the first skateboard company to be owned and operated by a Native American, and it now sponsors its own skateboard team. For Miles, a huge part of its mission is to support more positive activities for Native youth, whether in urban settings or on the reservation. The popular skate brand Volcom, a longtime supporter of Miles'

work, recently invited him to develop products for its Stone-Age line. Miles celebrated it on the website: "You are looking at design and art history created in Arizona for the skate crowd from the San Carlos Apache Nation. In an age when many clothing brands openly exploit Native themes, culture and art, Volcom did the opposite, they reached out to us as friends and family to support Apache Skateboards with complete respect for tribal Apache culture." – JRM

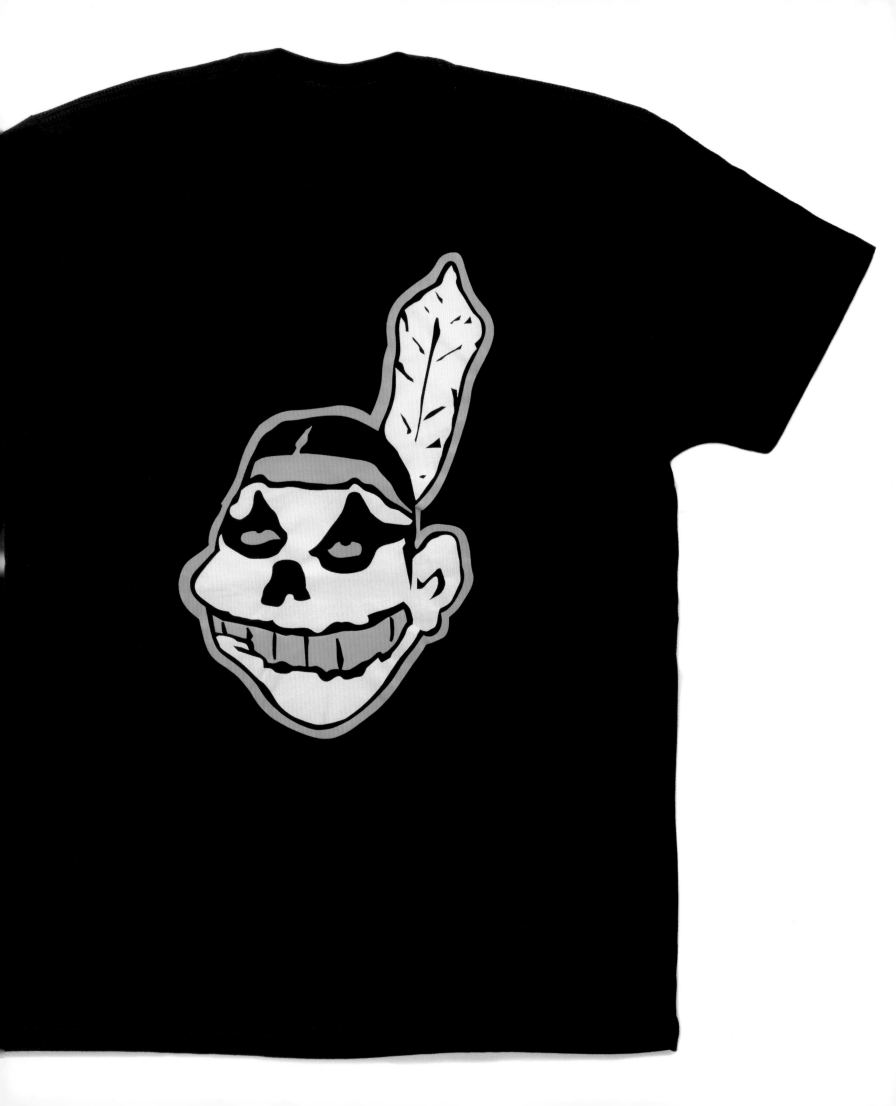

(left)
PLATE 57
Jared Yazzie
(born 1989, Diné [Navajo]) for *OxDx*
Mis-Rep T-shirt, 2014
Cotton
Peabody Essex Museum,
Salem, Massachusetts,
Gift of Karen Kramer, 2015.11.5

PLATE 58
Kevin Pourier
(born 1958, Oglala Lakota)
Rez Bans glasses, 2009
Buffalo horn, malachite, gold and white
mother of pearl, coral, lapis lazuli, sandstone,
metal, and glass
Courtesy the designer

PLATE 59
Cody Sanderson
(born 1964, Diné [Navajo]/Hopi/
Tohono O'odham/Nambé Pueblo)
Plume cuff, 2013
Sterling silver
Peabody Essex Museum,
Salem, Massachusetts,
Gift of Charles Franklin Sayre,
2014.21.2

Bethany Yellowtail
Apsáalooke [Crow]/ Northern Cheyenne

—

Bethany Yellowtail's dress is part of a fast-growing trend in fashion: the use of photoprint fabrics. Many designers are exploring this relatively new technology, choosing photographic source material and letting the color, texture, and silhouette of a garment follow from it.

This dress's original colors were cream and peach, but in this version the look is changed by the high-contrast black and white print. The fabric is cut so that the horizon in the photograph runs along the hems of the skirt and the sleeves; the filmy black band at the bottom evokes the flutter of wings and the spirit of birds in flight.

The dress creates fashion out of a beautiful photograph, making a new kind of hybrid artwork. But its designer has larger aims as well. The work is an extension of her larger project to build global awareness of the diversity of Native culture; it was created as a reward for a Kickstarter campaign for Project 562, photographer Matika Wilbur's effort to take photographic portraits of members of each of the over five hundred federally recognized tribes in the United States. Wilbur posted a poem about it on her blog:

> And then I realized that I am a part of this place.
> This earth.
> This breadth.
> It is I. And I am it.
> I am Human. I am enough.

Seen as part of a larger artistic and cultural effort incorporating photograph, poem, textile, and dress, the work is an important expression of Native heritage and a great design statement. The public seems to agree: the Kickstarter campaign raised an astonishing $250,000 for Wilbur's "Changing the Way We See Native America" project. — JC

PLATE 60
Bethany Yellowtail
(born 1988, Apsáalooke [Crow]/Northern Cheyenne) for *Project 562*
Yellowtail shift dress, 2013–14
Polyester, satin, and polyester mesh printed with photograph by Matika Wilbur (born 1984, Swinomish/Tulalip)
Courtesy Karen Kramer

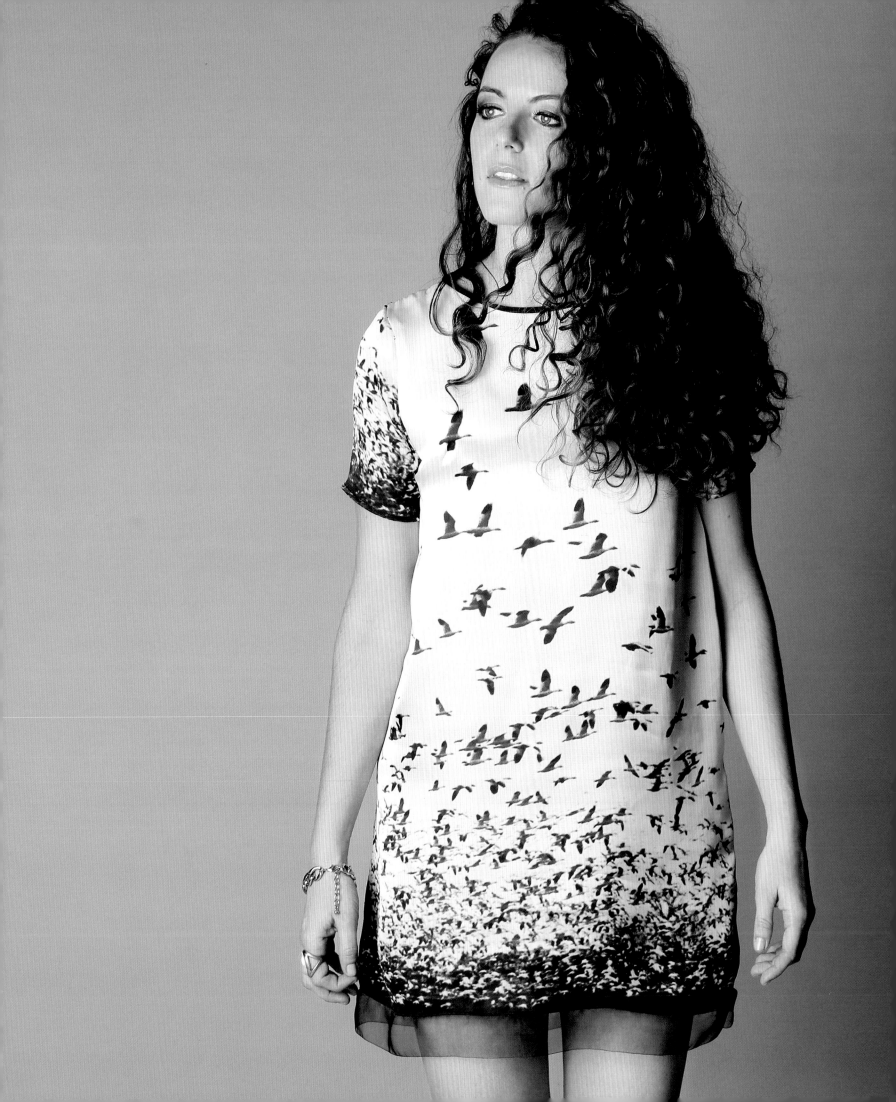

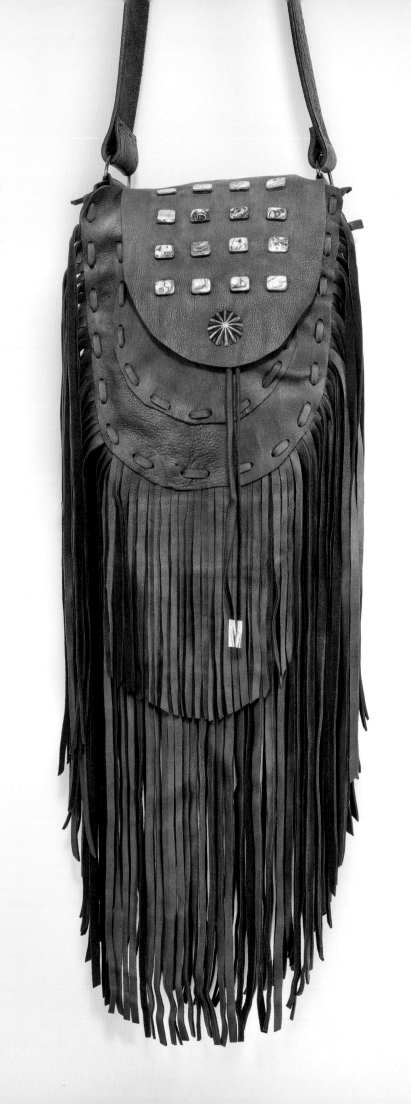

PLATE 61

Nathalie Waldman
(born 1974, Yellowknives Dene)
for *Urban Dogrib Designs*
Abalone Fringe bag, 2014
Deer hide, abalone shell, silver, and tin
Peabody Essex Museum, Salem, Massachusetts,
Gift of Karen Kramer
2015.11.1

PLATE 62

Paul E. LaPier
(born 1977, Haida/Tlingit)
Flat cap, 2014
Red cedar bark
Peabody Essex Museum,
Salem, Massachusetts,
Gift of Lynda Roscoe Hartigan
2014.55.1

Paul E. LaPier
Haida/Tlingit

—

Native heritage is literally woven into Paul LaPier's stylish flat cap, and its use of authentic Native materials and techniques makes it valuable to a new generation of consumers. Fashionistas are becoming more culturally conscious; they are increasingly interested in and sensitive to the distinction between authentic Native practices and designs appropriated from Native cultures. This creates greater interest in the work of designers like LaPier, who is helping to define what Native fashion will mean as his community moves forward.

LaPier's first experience of working with textiles was making fishing nets in his Native village; many in his community depend on the industry for sustenance and income. When he became an artist, he focused on weaving, and now makes all the component parts of his objects himself. Whether harvesting and curing cedar bark, prepping it for weaving, or making and using his natural dyes, LaPier is involved with every aspect of the manufacturing process, selecting and producing his materials by hand with great care. Each element has its own symbolic significance. Cedar bark represents the Northwest Pacific roots of his father's side of the family, while the sweetgrass he sometimes uses comes from the Plains heritage of his mother. LaPier uses traditional cedar bark weaving techniques to make hats in marketable contemporary shapes. Terms like "slow fashion," "locally sourced," "organic," and "culture-based craftsmanship" could all apply to his work; ideas like these are changing the language of fashion. —JC

PRO-
VOCAT-
EURS

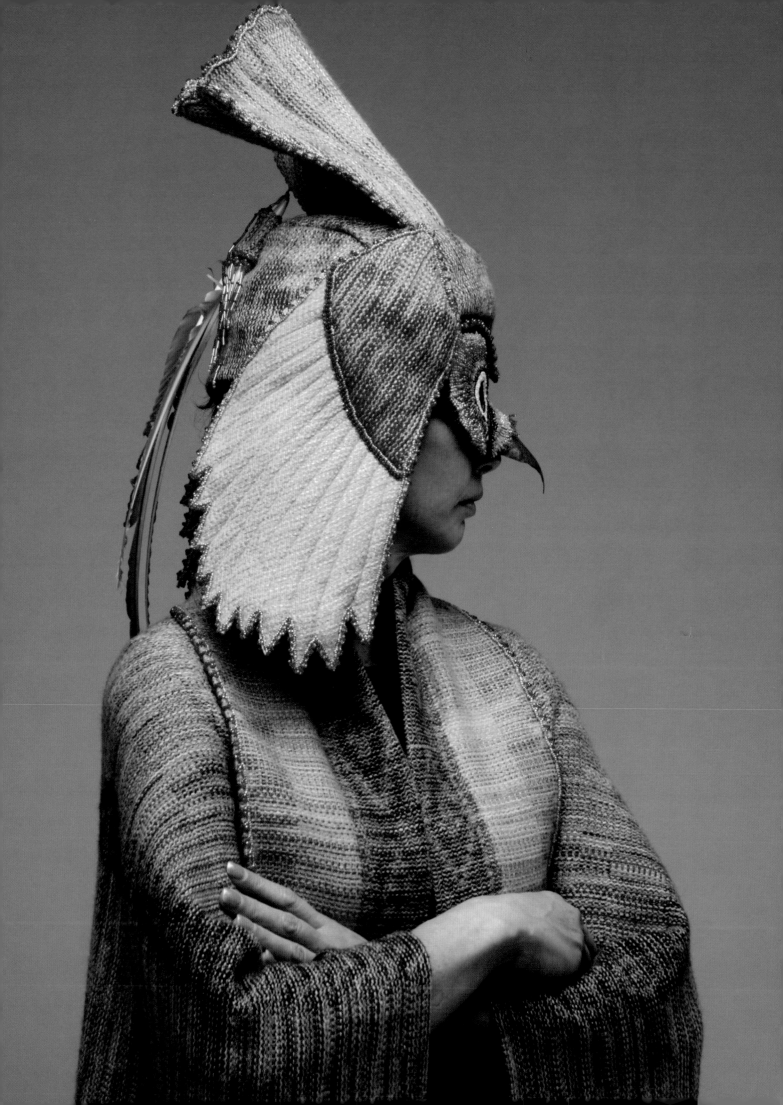

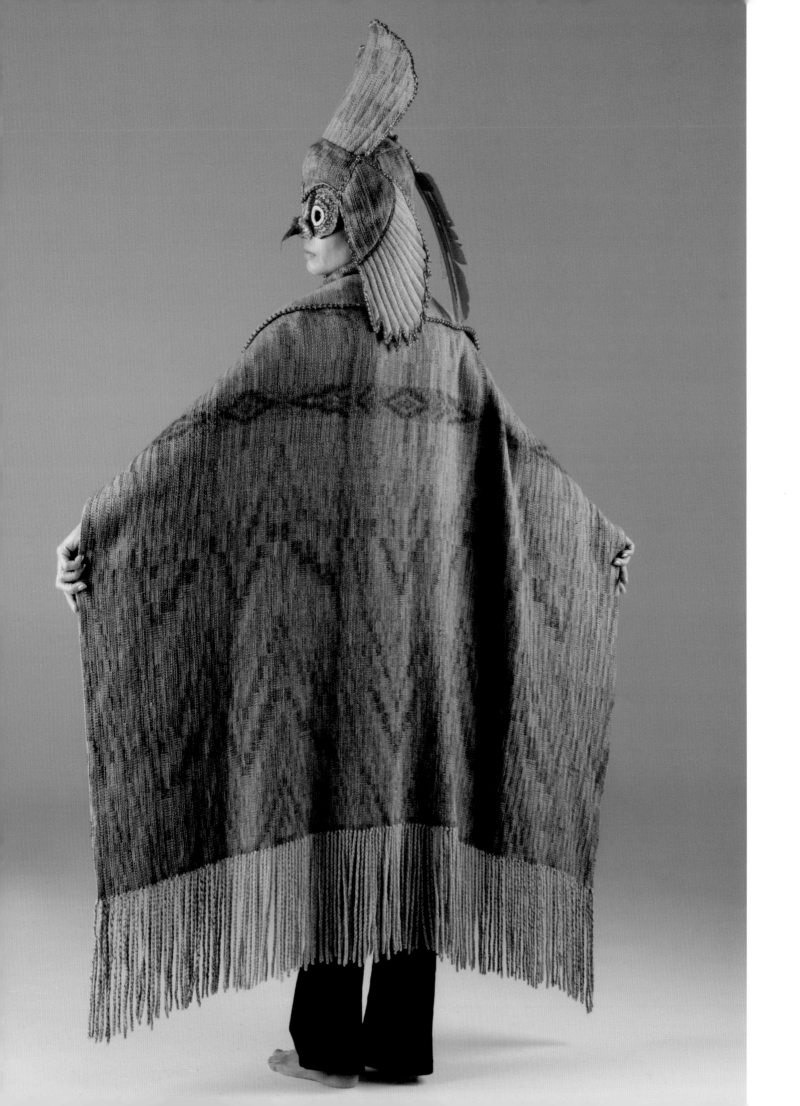

Margaret Roach Wheeler
Chickasaw

—

This dazzling ensemble turns a two-dimensional piece of fabric into a three-dimensional sculpture: an animal head that comes to life when worn. Margaret Roach Wheeler's influences include mainstream fashion designers Norma Kamali, Thierry Mugler, and Issey Miyake, but also her own Native great-great-great-grandmother, after whom her "Mahotan" collection was named.

In the Southeastern Native world-view, birds are important figures, represented in ceremonies by feathered dancers. The owl demands particular respect as a messenger from the spirit world who often comes to warn the tribe of danger. Here, Wheeler's impressive weaving skills help her to construct feathers, beak and robe. This is just one of many spirit figures in the "Mahotan" collection, which also includes Raven, Crane, and Snow Goose. The ensembles honor the role birds continue to play in Chickasaw and Choctaw cultures. –JRM

(previous page and left)
PLATE 63
Margaret Roach Wheeler
(born 1943, Chickasaw)
for *Mahota Handwovens*
The Messenger (The Owl) cape and headpiece,
"Mahotan" Collection, 2014
Silk/wool yarn; silk/wool yarn, metal,
silver, glass beads, and peacock feathers
Courtesy the designer

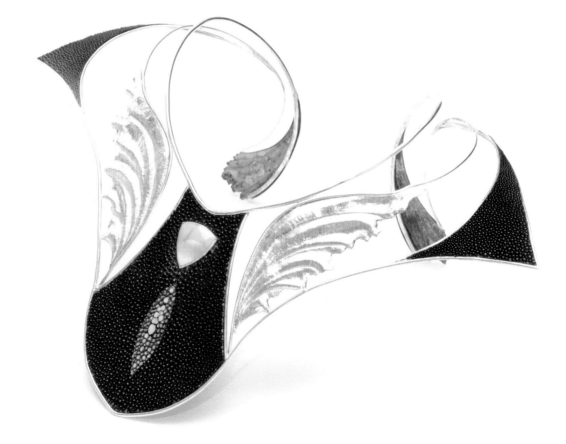

(right)
PLATE 64
Kristen Dorsey
Stingray breastplate, "Shokmalli'"
Collection, 2013

Kristen Dorsey

Chickasaw

—

This suite looks like it was made for a celestial warrior queen to wear in an intergalactic battle. You know the type—the powerful heroine ready to unleash the fury of the heavens. Dramatic, you say? Heck yes. Epically so.

Kristen Dorsey's breastplate and ring are part of her "Shokmalli'" collection, which is inspired by the Chickasaw deity Sky Serpent. As Dorsey explains on her website, the winged snake is a powerful figure in her tribe's cosmology:

> Fluidity and grace, light and shadow, keeper of the secrets of the stars, she controls the movements of celestial bodies. The wind is her breath. She is the ancient one. The sky serpent, soft as a delicate spring breeze fluttering blades of grass, and terrifying as electric bolts crack across the sky, trees are uprooted, buildings toppled as rain floods the fragile life of earth. Giver of life, taker of life, seductive as the twinkle of starlight in the darkened night.

The ring and breastplate embody the duality of the Sky Serpent figure. The snake's angular lines are offset by delicate wings whose feathers are picked out in chasing and repoussé; they create the illusion of sweeping movement. Cerulean larimar, shimmering copper, and the dark expanse of stingray skin together evoke the sky, sun, and the serpent's scales. Day and night. Ethereal beauty and eternal power. With these objects, Dorsey dances between the imposing and the delicate, using them to protect the wearer and to command attention from the viewer. –MMK

PLATE 65
Kristen Dorsey
(born 1985, Chickasaw)
Stingray breastplate and ring, "Shokmalli'"
Collection, 2013–14
Sterling silver, stingray leather,
larimar, copper, and brass
Courtesy Kristen Dorsey and Sarah Jay

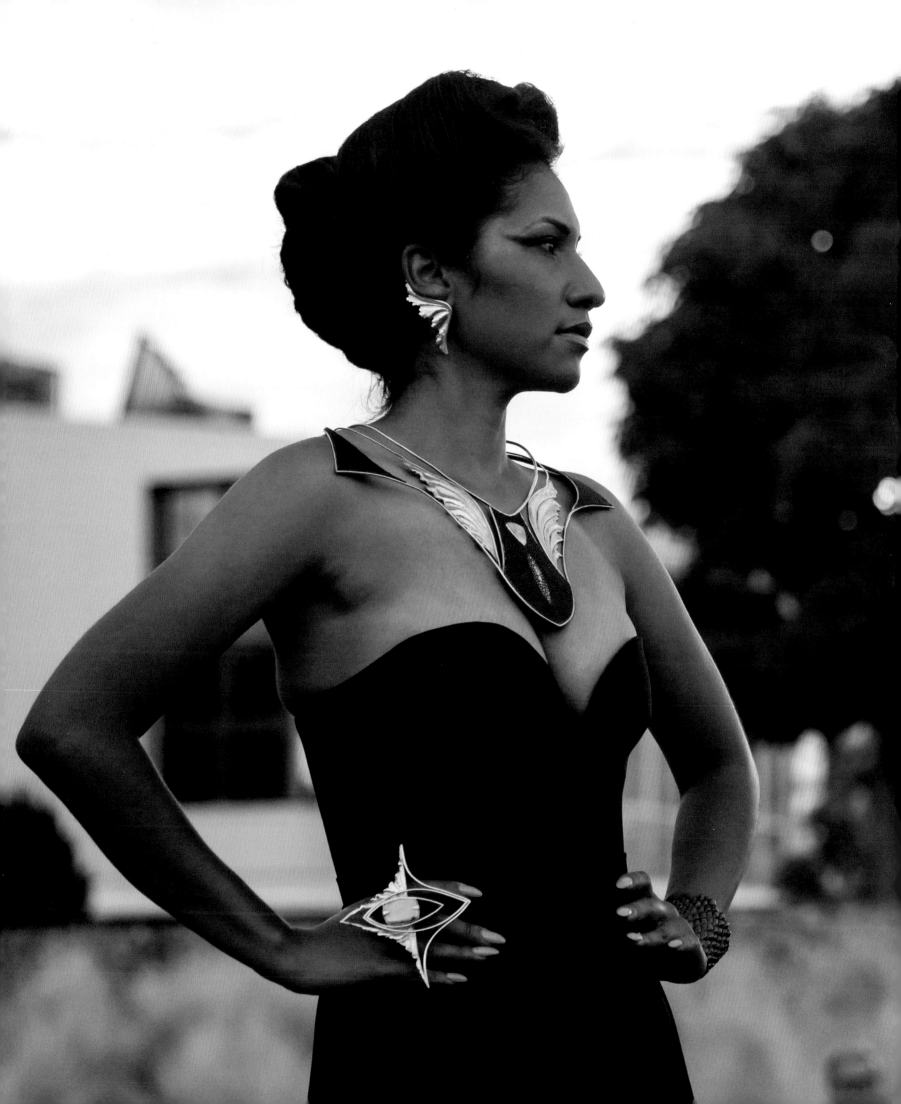

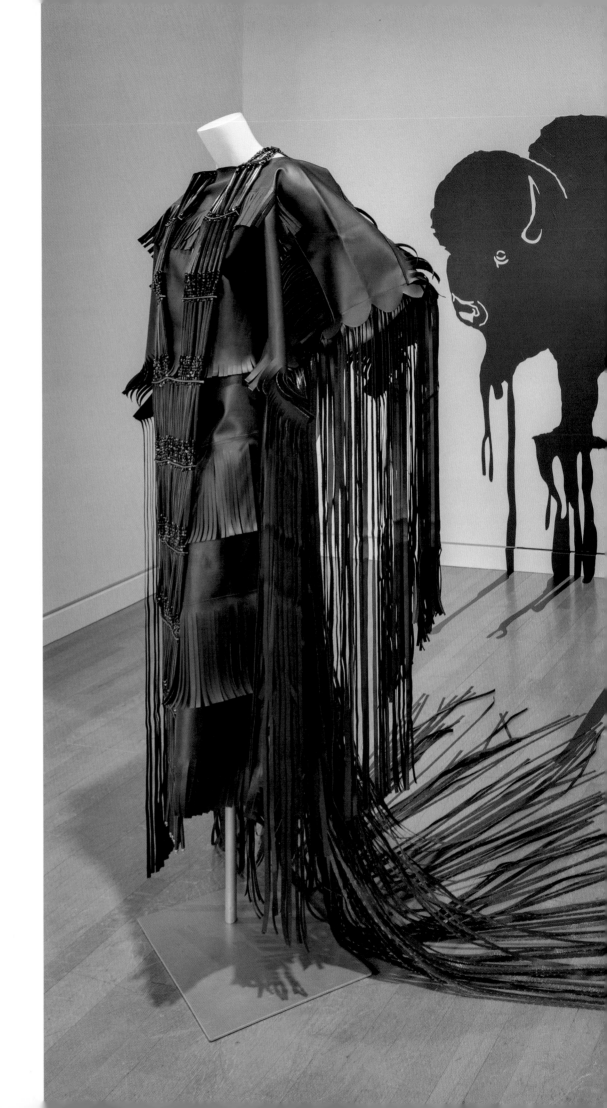

PLATE 66
Wendy Red Star
(born 1981, Apsáalooke [Crow]) and
Terrance Houle
(born 1975, Blood)
*Sikahpoyíí, bishée, baleiíttaashtee
(Motor Oil, Buffalo, Dress)*, 2013
Vinyl and plastic beads
Courtesy the designers and Portland Art Museum,
Oregon, Museum purchase: Funds
provided by Barbara Christy Wagner,
© Wendy Red Star, 2014.19.1a-c

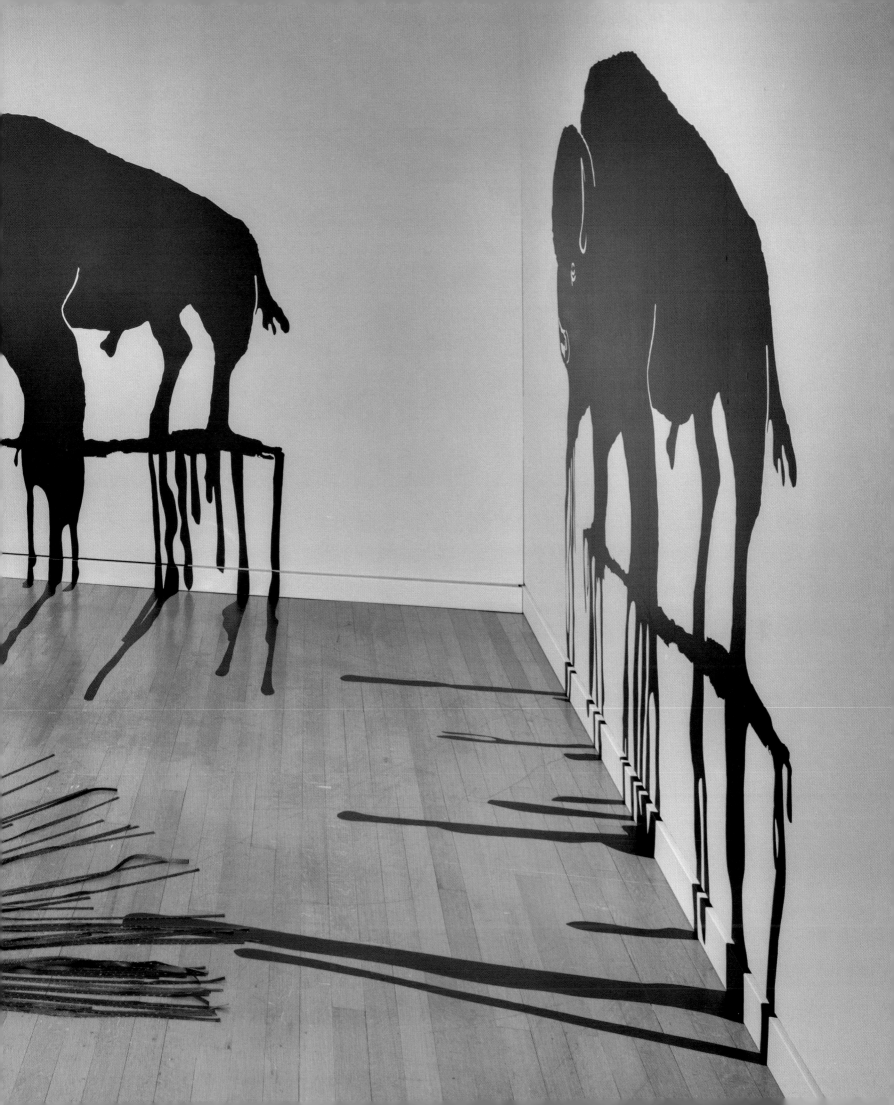

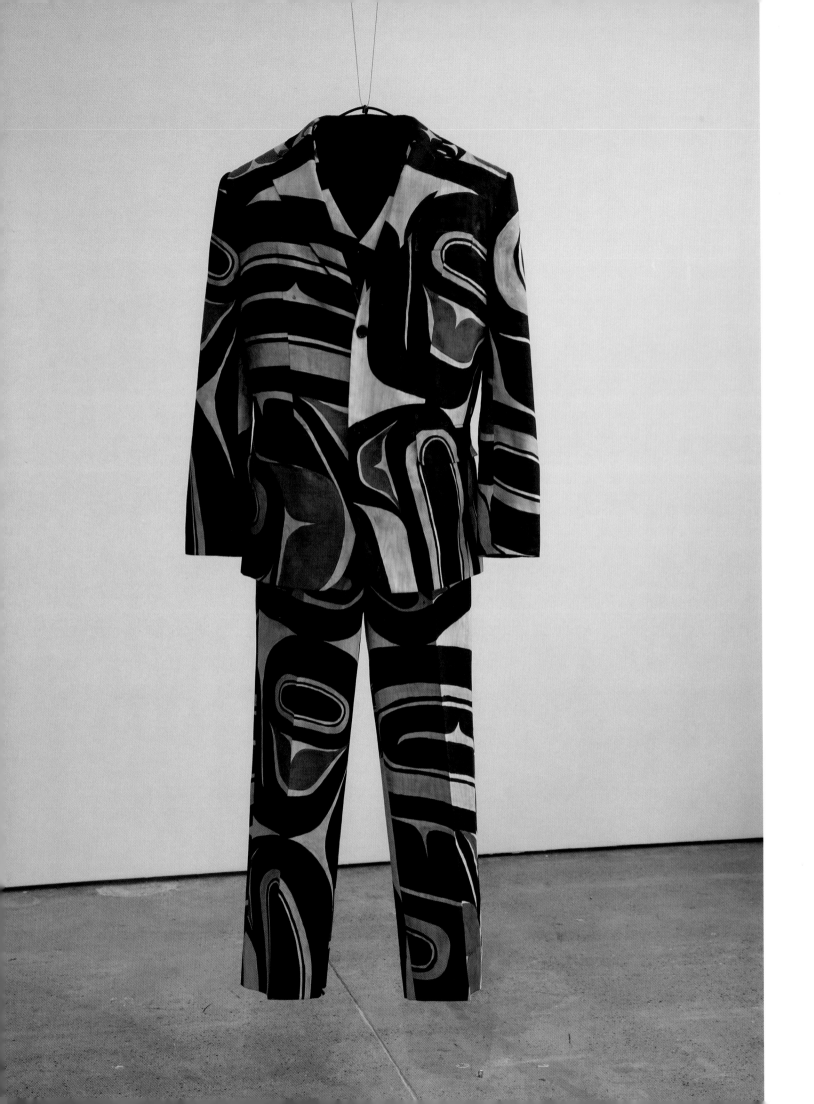

Tommy Joseph
Tlingit

—

Joseph's *Eagle Wolf Suit*, a collaboration with Philadelphia's Fabric Workshop and Museum, is equally at home on the runway and in a museum display. Like totem poles, which function as both status symbols and storytelling tools, this suit makes a bold statement.

The best menswear, like all good clothes, adheres to traditional forms. Even the most daring dandies want a suit whose style and line they can recognize. Though this one pushes the envelope in terms of color and pattern, its cut conforms to menswear traditions, keeping it wearable.

Joseph also makes totem poles, and the black formline pattern of eagle and wolf motifs, accentuated in shades of red, green and tan, comes straight from them. As a Sitka wood carver, he is well-versed in his Tlingit community's history and art traditions, and he uses the tribe's iconography to tell stories about its contemporary life. This ability makes him well-suited to the world of fashion, a field which builds on the past while capturing the imagination of younger people. –JC

Lisa Telford
Haida

—

The simple asymmetrical frame of Lisa Telford's *PochaHaida* dress amplifies its impact. Its minimal, sculpted silhouette makes the materials the message, while the fine weaving technique used to make the red cedar-bark textile is a part of Telford's cultural inheritance. The faux leather fringe evokes more traditional shredded cedar bark and suede versions, but also nods to contemporary concerns about the environment and animal rights.

Beautiful textiles have always been essential to Native spiritual life, whether they are used in garments or in ceremonial objects. They enhance aesthetics and symbolism, and the artistry used to create them is a kind of natural extension of a spiritual practice. Telford's handwoven dress shows how time-honored weaving techniques and Haida textiles can fit into modern cultural exchanges around clothing, protecting Native traditions and ensuring their continuity. –JC

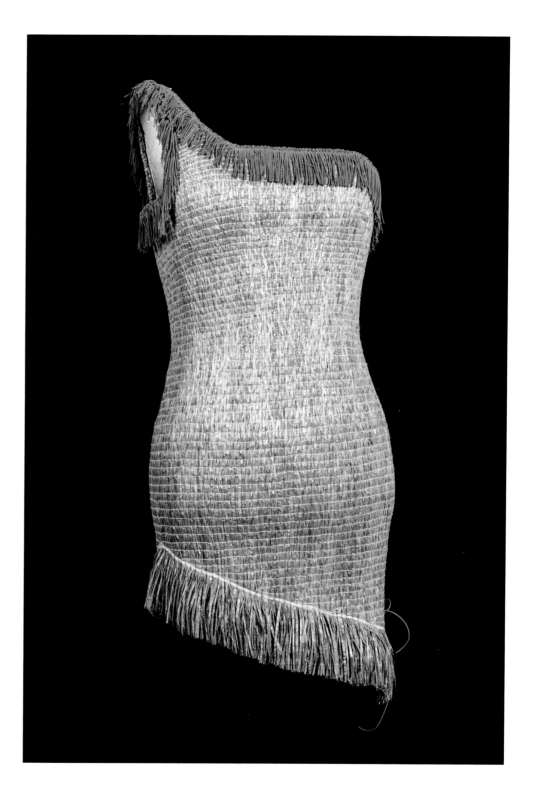

PLATE 68
Lisa Telford
(born 1957, Haida)
PochaHaida dress, 2009
Red cedar bark, cordage, and faux leather fringe
Bill Holm Center for the Study of Northwest Coast Art,
Burke Museum, Seattle,
2014-50/1

(left)
PLATE 67
Tommy Joseph
(born 1964, Tlingit)
Eagle Wolf Suit prototype, 2009
Hand-painted cotton sateen
Courtesy the designer and The Fabric Workshop
and Museum, Philadelphia

David Gaussoin
Wayne Nez Gaussoin
Diné [Navajo])/Picuris Pueblo

—

The feather boa is one of those accessories that just screams flamboyance. Thrown on by anyone, whether Hulk Hogan, Elton John, a 6-year-old playing dress up, or nonagenarian style icon Iris Apfel, it turns the fashion volume to 10. In this collaboration, brothers David and Wayne Nez Gaussoin kick it up to 11. Their avant-garde version can't be drawn luxuriously through the hands, like Betty Boop's soft pink feathers of yore. Instead, *Postmodern Boa* is blood-red, with sharp-looking angular feather protrusions. Like the animal from which it gets its name, this is the kind of boa that might encircle—even strangle—its prey. In other words, it's totally killer.

The Gaussoin brothers have become known for edgy wearable art that begs to be paraded down the catwalk. From David's industrial, diamond-plated steel earrings to Wayne's chocolate-colored "Soft Serve" ring, their street-style designs manage to feel dangerous and whimsical at the same time. Their unconventional work may not please those for whom Native American jewelry consists only of silver concho belts and turquoise necklaces, but as 21st-century artists with a long family tradition in the field, the brothers Gaussoin have the confidence to interpret their culture in a contemporary—even a progressive—way. Their work is inspired by their Native heritage, but is definitely in keeping with high-end fashion today. – MMK

PLATE 69
Summer Peters
(born 1977, Ojibwe) for *Mama Longlegz*
Artist models her *Asymmetrical Necklace*, 2013
Glass beads, wool broadcloth, and metal
Courtesy the designer

(right)
PLATE 70
David Gaussoin
and **Wayne Nez Gaussoin**
(born 1975 and 1982,
Diné [Navajo])/Picuris Pueblo)
Postmodern Boa, 2009
Stainless steel, sterling silver, enamel
paint, and feathers
Courtesy the designers

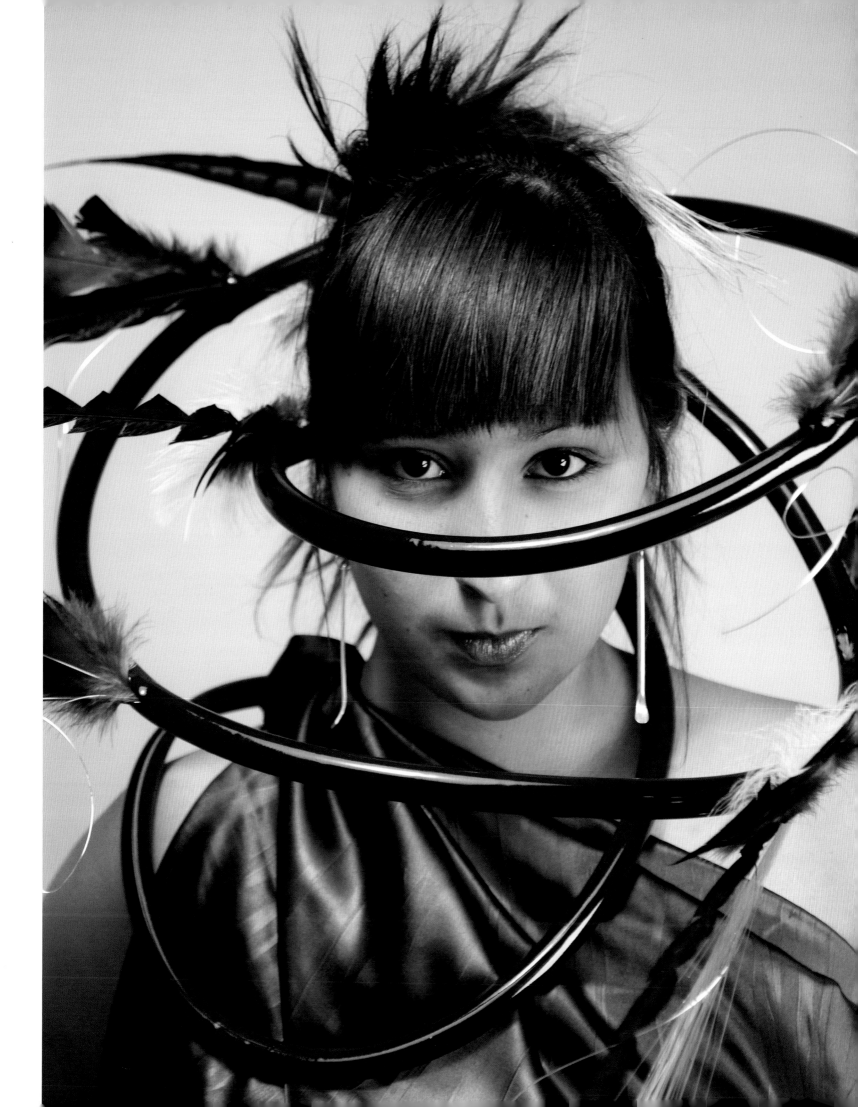

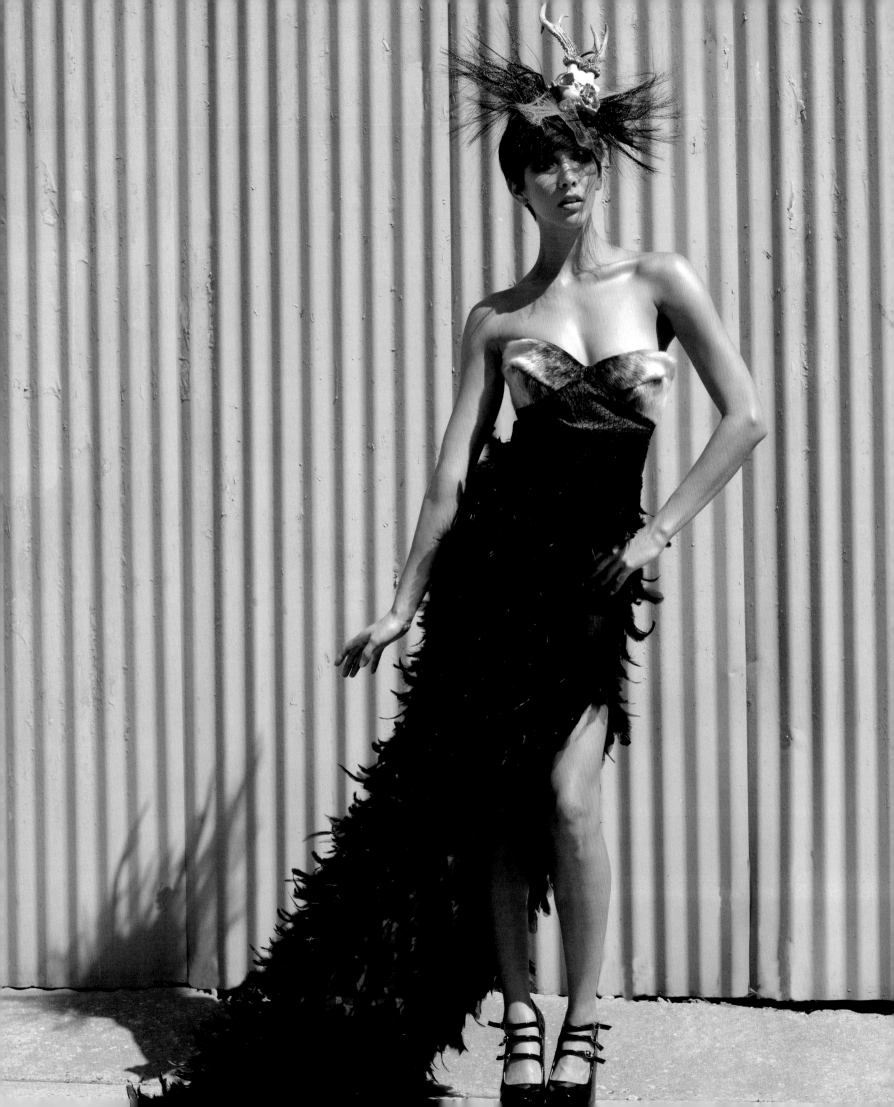

Sho Sho Esquiro
Kaska Dene/Cree

—

In the world of fashion, a badly sewn garment can cause "wardrobe malfunction," resulting in embarrassment or, worst case, a fine (take note, Super Bowl halftime show hopefuls!). But in the Yukon, Canada's northernmost region, where Sho Sho Esquiro grew up, careless sewing can mean frostbite. Esquiro has understood the importance of skillful tailoring from a young age, and her work is remarkable both for its technical sophistication and for its artistry, qualities associated equally with European couture houses and with indigenous art.

Esquiro uses surprising texture and color combinations to update classic feminine silhouettes. This dress (its title, *Wile Wile Wile*, means "the sound of wings in flight" in the Kaska Dene language) combines carp skin and animal fur. Its dramatic juxtapositions are the hallmark of Esquiro's glamorous aesthetic. The dress is part of the "Day of the Dead" collection, which honors Esquiro's departed loved ones—the garments are designed to be worn by

them at an imagined joyful reunion celebration. Taking visual cues from the Mexican holiday of the same name, and also from the work of the artist Frida Kahlo, the pieces from this line, many of which are accented with animal-skull fascinators, have a dark, romantic beauty. In Fall 2014, Esquiro debuted another memorial-themed collection, this one entitled "Worth Our Wait in Gold." It honors the 1,200 Canadian First Nations women who have disappeared or been murdered since 1980 [FIG. 3].

Over the years, the beauty of Esquiro's work has won her a global following, and she now lives in Vancouver, traveling frequently for work. This alluring evening gown expresses the deep love and longing she still feels for her tribal home, its land, animals, and people. Although she no longer lives in the Yukon, Esquiro is devoted to her Kaska Dene community, supporting indigenous rights (violence against Native women is one of her causes) while building her business and exploring the world. —MMK

Pilar Agoyo

Ohkay Owingeh
[San Juan]/Cochiti/Kewa
[Santo Domingo] Pueblos

—

Pilar Agoyo uses ancient motifs from
Native design in this slick red and black
vinyl dress, but innovates by using
new materials, processes and silhouettes.
A student of Wendy Ponca [PLATE 16],
Agoyo followed her mentor in updating
and redeploying traditional designs,
creating garments with a modern, even
groundbreaking aesthetic. She learned
stitchwork from Ponca, and her clothes
are always beautifully sewn.

In this dress, as in much of her work,
Agoyo uses a complicated reverse-
appliqué process, cutting shapes out of
the fabric, then filling them in, in this
case in black vinyl. The process is delicate
and time-consuming—especially when
using such a notoriously tricky material.
In the end, though, she made a strap-
less dress that's part rock and roll, part
futuristic Native, part Pueblo princess,
and overall, totally fabulous. – JRM

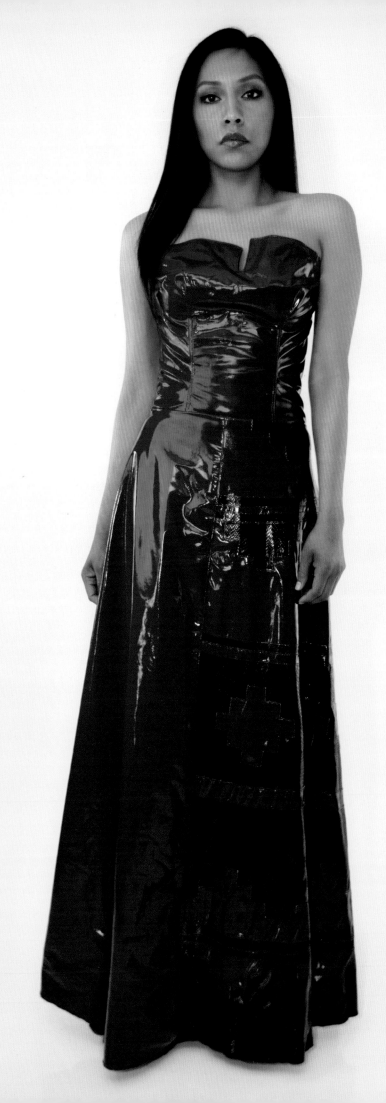

Barry Ace
Anishinaabe [Odawa]

—

Visual artist Barry Ace uses found objects and computer components to create garments that are also works of art. Like the famous Belgian design house Maison Martin Margiela, whose Artisanal collection "upcycles" discarded items into haute couture, Ace does more than simply recycle. He completely reimagines the cast-off remnants of our culture of consumption, turning assemblage into art.

Long before Duckie Brown's colorful beaded wingtips made their way into men's wardrobes, Ace had made his own foray into fashionable men's footwear. He uses the leftovers of the digital age in objects that celebrate and reflect his Native heritage. Resisters and flat ceramic capacitors take the place of beads and quills, while clusters of coated copper wire stand in for fringe on these square-toed lace-up shoes. The substitutions comment on the impact of technology on Native culture. Ace's object-based work builds a new circuit of ideas that is exciting for devotees of Native culture and fashion aficionados alike. – JC

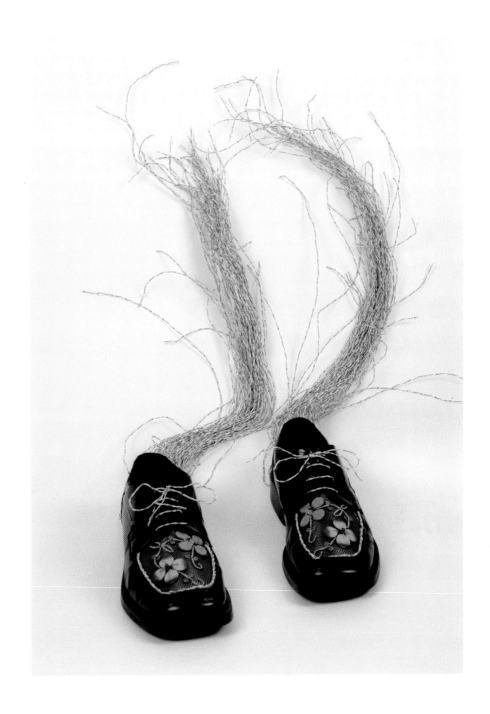

PLATE 73
Barry Ace
(born 1958, Anishinaabe [Odawa])
Reaction shoes, 2005
Found leather shoes, computer components,
wire, paper, rubber, and metal
Courtesy John Cook

(left)
PLATE 72
Pilar Agoyo
(born 1972, Ohkay Owingeh [San Juan]/
Cochiti/Kewa [Santo Domingo] Pueblos)
Dress, 2009
Vinyl
Courtesy the designer

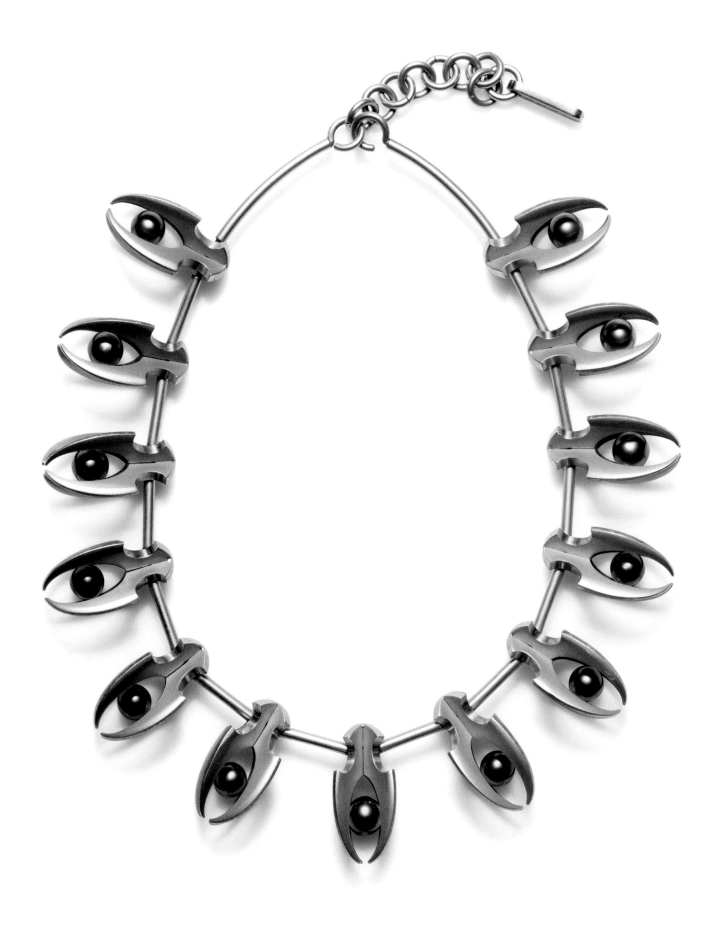

PLATE 74
Pat Pruitt
(born 1973, Laguna Pueblo)
Tahitian Bondage necklace, 2008
316L stainless steel
and natural Tahitian pearls
Courtesy Catherine Sullivan-Kropa
and William Kropa

SELECTED BIBLIOGRAPHY

Bazylinski, Alison Rose. "Dressing Indian: Appropriation, Identity, and American Design, 1940–1968." Master's thesis, University of Nevada, Las Vegas, 2013.

Bernstein, Bruce. *Santa Fe Indian Market: A History of Native Arts and the Marketplace*. Santa Fe: Museum of New Mexico Press, 2012.

Bunn-Marcuse, Kathryn. "In(Tension)al Enchantment." *FiberArts*, January/February 2010, 52–53.

Cervenka, Mark, and Teri Greeves. *Storied Beads: The Art of Teri Greeves*. Gallery brochure, Houston: O'Kane Gallery, 2011.

Cutropia, Rose Marie. "Lloyd 'Kiva' New: Artist, Educator and Visionary, from the Lloyd H. New Papers in the Archives Collection at the Institute of American Indian Arts." Bachelor's thesis, Santa Fe: Institute of American Indian Arts, 2014.

Davis, Fred. *Fashion, Culture, and Identity*. Chicago: University of Chicago Press, 1992.

Deloria, Philip J. *Playing Indian*. New Haven: Yale University Press, 1998

Diaz, RoseMary. "Pilar Agoyo (OhKay Owingeh-Cochiti-Kewa Pueblos)." *First American Art Magazine,* Fall 2014, 26–31.

DorothyGrant.com. "Dorothy Grant, Haida Artist." http://www.dorothygrant.com/artist/.

Dorsey, Kristen. "One-of-a-Kind Stingray and Larimar Breastplate." http://www.kristendorseydesigns.com/shop-collections/one-of-a-kind-stingrey-breastplate.

Dubin, Lois Sherr, Togashi, Denise Wallace, and Samuel Wallace. *Arctic Transformations: the Jewelry of Denise and Samuel Wallace*. [United States]: Easton Studio Press/Theodore Dubin Foundation, 2005.

Duncan, Fiona, and Anna Soldner. "Ghetto Fabulous: 13 Voices Speak on Fashion's Appropriation of Urban Culture." *Bullett Media*, January 9, 2014. http://bullettmedia.com/article/13-voices-speak-on-fashions-appropriation-of-urban-culture/.

EighthGeneration.com. "Bio." *8THGEN by Louie Gong*. http://eighthgeneration.com/pages/bio.

Fox, Judith Hoos. *Pattern Language: Clothing as Communicator*. Medford, MA: Tufts University, 2005.

Geczy, Adam, and Vicki Karaminas. *Fashion and Art*. London: Berg, 2012.

Godreche, Dominique. "The Natives Strike Back: Pueblo Revolt Reimagined, 'Star Wars' Style." *Indian Country Today Media Network.com*, October 24, 2013. http://indiancountrytoday-medianetwork.com/2013/10/24/natives-strike-back-pueblo-revolt-reimagined-star-wars-style-151904.

Green, Rayna. "The Pocahontas Perplex: The Image of Indian Women in American." *The Massachusetts Review* 16, no. 4, Autumn 1975, 698–714.

Greeves, Teri. "Orlando Dugi: Diné Beadwork Artist and Fashion Designer." *First American Art Magazine,* Spring 2013, 13–16.

———. "Mohawk Quiltmaker Carla Hemlock." *First American Art Magazine*, Spring 2014, 24–29.

Her Many Horses, Emil. *Identity by Design: Tradition, Change, and Celebration in Native Women's Dresses*. New York: HarperCollins, in association with the National Museum of the American Indian, Smithsonian Institution, 2007.

"Indian Designer Wins Renown." *Winona Daily News*. March 16, 1955, 25. www.newspapers.com/newspage/43585690.

Jennings, Helen. *New African Fashion*. Munich: Prestel, 2011.

Jones, Adrienne, Paula Coleman, and Walter Greene. *Black Dress: Ten Contemporary Fashion Designers*. Gallery brochure, New York: Pratt Manhattan Gallery, 2014.

"Julius the Monkey's Native American Makeover: How Paul Frank Industries Turned a Backlash into a Collaboration by Joining Forces with its Harshest Critics," *DailyMail.com*, August 19, 2013. http://www.dailymail.co.uk/femail/article-2397489/How-Paul-Frank-Industries-turned-backlash-collaboration-harshest-critics.html#ixzz3ORbMz2BE.

Keene, Adrienne. "Paul Frank Offends Every Native Person on the Planet with Fashion Night Out 'Dream Catchin' Pow wow." *Native Appropriations* (blog), September 9, 2012. http://nativeappropriations.com/2012/09/paul-frank-offends-every-native-person-on-the-planet-with-fashion-night-out-dream-catchin-pow-wow.html.

Kennedy, Alicia, Emily Banis Stoehrer, and Jay Calderin. *Fashion Design, Referenced: a Visual Guide to the History, Language & Practice of Fashion*. Beverly, MA: Rockport Publishers Inc., 2013.

Knox, Kristin. *Culture to Catwalk: How World Cultures Influence Fashion*. London: A. & C. Black, 2011.

Kondo, Dorinne K. *About Face: Performing Race in Fashion and Theater*. New York: Routledge, 1997.

Lockridge, Kay. "Beyond Buckskin and Fringe: Clothing Contestants Push Fashion Boundaries while Honoring Tradition." *Indian Market Magazine,* August 2012, 102–103.

Madsen, Axel. *Chanel: A Woman of her Own*. Holt Paperbacks, 1991.

MargaretRoachWheeler.com. "Margaret Roach Wheeler: Mahota Handwovens." http://www.margaretroachwheeler.com/.

McFadden, David Revere, and Ellen Taubman, eds. *Changing Hands: Art Without Reservation 3: Contemporary Native North American Art from the Northeast and Southeast*. New York: Museum of Arts and Design, 2012.

Metcalfe, Jessica R. "Artist Profile | Caroline Blechert." *Beyond Buckskin* (blog), July 19, 2013. http://www.beyondbuckskin.com/2013/07/artist-profile-caroline-blechert.html.

——. "More than Just a Trend: Rethinking the 'Native' in Native Fashion." *First American Art Magazine,* Spring 2013, 36–39.

——. "Designer Profile | Paul Rowley." *Beyond Buckskin* (blog), November 13, 2012. http://www.beyondbuckskin.com/2012/11/designer-profile-paul-rowley.html.

——. "Native Fashion and the Squaw Dress." *Beyond Buckskin* (blog), March 24, 2012. http://www.beyondbuckskin.com/2012/03/native-fashion-and-squaw-dress.html.

——. "Native Designers of High Fashion: Expressing Identity, Creativity, and Tradition in Contemporary Customary Clothing Design." PhD diss., University of Arizona, 2010.

——. "Designer Profile | Lloyd Kiva New." *Beyond Buckskin* (blog), March 29, 2010. http://www.beyondbuckskin.com/2010/03/designer-profile-lloyd-kiva-new.html.

——. "Designer Profile | Lloyd Kiva New: The Father of Contemporary Native Fashion." *Beyond Buckskin* (blog), August 30, 2009. http://www.beyondbuckskin.com/2009/08/lloyd-kiva-new-father-of-contemporary.html.

Miller, Linda. "Designer from Oklahoma Finds Fashion-World Success," *The Oklahoman* (Oklahoma City), March 4, 2010. www.newsok.com/designer-from-oklahoma-finds-fashion-world-success/article/3443592.

Museum of Modern Art. "Checklist for Textiles U.S.A." Textiles U.S.A, exhibition checklist, 1956. http://www.moma.org/momaorg/shared/pdfs/docs/press_archives/2091/releases/MOMA_1956_0072_62.pdf?2010.

Ortiz, Virgil. "Virgil Ortiz: Never Stop." Interview by Charles King. August 8, 2014, http://www.virgilortiz.com/virgil-ortiz-never-stop/.

Pardue, Diana. *Contemporary Southwestern Jewelry*. Layton, UT: Gibbs Smith Publisher, 2007.

Parezo, Nancy J. "The Indian Fashion Show." In Phillips, Ruth B. and Christopher B. Steiner, eds. *Unpacking Culture: Art and Commodity in Colonial and Postcolonial Worlds*. Berkeley: University of California Press, 1998.

Pham, Minh-Ha T. "Fashion's Cultural-Appropriation Debate: Pointless." *The Atlantic*, May 15, 2014. http://theatlantic.com/entertainment/archive/2014/05/cultural-appropriation-in-fashion-stop-talking-about-it/370826/.

Root, Regina A. "Powerful Tools: Towards a Fashion Manifesto." *International Journal of Fashion Studies* 1, no. 1 (2014), 119–126.

Tulloch, Carol. "Style—Fashion—Dress: From Black to Post-Black." *Fashion Theory* 14, no. 3, 2010, 273–304.

VirgilOrtiz.com. "About VO." http://www.virgilortiz.com/about/.

"voices: contemporary artists speaking about their lives." *Indian Artist Magazine*, 1, 1, Spring 1995, 36–47

Watson, Mary Jo. "Crow Interdisciplinary Artist Wendy Red Star." *First American Art Magazine* Winter 2014, 34–39.

Wilbur, Matika. "Road Poetry." *Project 562* (blog), June 15, 2013. http://matikawilbur.com/blog/blog/road-poetry.

Williams, Lucy Fowler. "From the Field—Guerilla Fashion: Textiles in Motion Push Change in Indian Art." *Expedition Magazine*, 53, 1, Spring 2011, 9–10. http://issuu.com/pennmuseum/docs/expedition-magazine-summer2011/16?e=0.

Willmott, Cory. "Designing, Producing and Enacting Nationalisms: Contemporary Amerindian Fashion in Canada." In *The Force of Fashion in Politics and Society: Global Perspectives from Early Modern to Contemporary Times*, edited by Beverly Lemire, 167–190. London: Ashgate Publishers, 2010.

Wood, Margaret. *Native American Fashion: Modern Adaptations of Traditional Designs*. New York: Van Nostrand Reinhold, 1981.

INDEX

INDEX

PHOTOGRAPHY CREDITS

All artwork © the artist or artist's estate unless otherwise noted; all images appear courtesy of the lenders unless otherwise noted. Images courtesy of the following organizations and individuals.

2, 132: Courtesy of Thosh Collins. Model: Lailani Dawn Mekeel.

4, 14, 57, 64–65, 67, 82, 88, 91, 97–98, 107, 115 (bottom), 119, 136: © 2015 Peabody Essex Museum. Photo by Walter Silver.

6, 44: © 2015 Peabody Essex Museum. Photo by Thosh Collins. Model: Louisa Belian.

10, 25, 40–41, 95–96, 102–103, 105, 108, 110 (all), 114: © 2015 Peabody Essex Museum. Photo by Kathy Tarantola.

15: © Frazer Harrison/Getty Images, Inc.

16: Courtesy of Elizabeth R. Rose Photography.

17: Courtesy of Sho Sho Esquiro.

18 (top): Courtesy of Ralph Lauren.

18 (bottom): Courtesy of Thosh Collins. Model: Martin Sensmeier.

19 (top): Courtesy of Frank Buffalo Hyde.

19 (bottom): © 2007 Peabody Essex Museum. Photo by Mark Sexton.

20 (far left): © Dan and Corina Lecca. Courtesy of Walter Van Beirendonck.

20 (left): Courtesy of Barbara Moore.

22 (top): Courtesy of Institute of American Indian Arts.

22 (bottom): Courtesy of Jessica R. Metcalfe.

23: Courtesy of Robert L. Knudsen Presidential Photo Collection.

24, 31 (bottom), 75: © 2006 Peabody Essex Museum. Photo by Mark Sexton and Jeffrey Dykes.

26 (top): Courtesy of University of Wyoming American Heritage Center, Richard Throssel papers.

26 (bottom), 90: Courtesy of Bethany Yellowtail. Photo by Thosh Collins. Model: Jade Willoughby.

27: © Neal Preston/Corbis.

28 (top): Courtesy of Mr. Emil Her Many Horses, NMAI.

28 (bottom), 70–71: Courtesy of Teri Greeves.

31 (top): National Portrait Gallery, Smithsonian Institution/Art Resource, NY.

32: © 2015 Agnes Martin/Artists Rights Society (ARS), New York. Digital image © The Museum of Modern Art/Licensed by SCALA/Art Resource, NY.

33: © 2015 Georgia O'Keeffe Museum/ Artists Rights Society (ARS), New York. Photo courtesy Georgia O'Keeffe Museum, Santa Fe/ Art Resource, NY.

35: © 2014 AETN. Photo by Barbara Nitke.

36–37: Courtesy of Orlando Dugi.

39: Courtesy of Derek Jagodzinsky/LUXX ready-to-wear. Model: Mariah Tang.

42, 51: © 2015 Peabody Essex Museum. Photo by Thosh Collins.

43: Courtesy of Kelly Cappelli.

46–47: Courtesy of Zadro Vizualz, Jason S. Ordaz.

48: Courtesy of Gerald R. Ford Presidential Library.

49: Courtesy of Gerald R. Ford Museum, Grand Rapids, Michigan.

50: Courtesy of Maria Samora.

53: Courtesy of Robin Waynee.

54: Courtesy of Mike Waddell, Waddell Trading.

55: © Catwalking.com.

56: Courtesy of Dorothy Grant.

59: Courtesy of Sarah Elsberry Stock.

61: © Valerie Santagto.

62–63: National Museum of the American Indian, Smithsonian Institution. Photo by Ernest Amoroso.

68: © Eric Boman.

73: Courtesy of Kent Monkman. Photo by Brian Boyle.

74, 83, 86–87, 118: © 2015 Peabody Essex Museum. Photo by Dennis Helmar Photography.

76: Courtesy of Duane Wilcox. Photo by Kayla M. Schubert.

77, 89: © Heard Museum, Phoenix, Arizona.

78–80: Courtesy of Autry National Center, Los Angeles. © Niio Perkins.

81: © Sealaska Heritage Institute. Photo by Brian Wallace.

84, 100, 134: © 2015 Peabody Essex Museum. Photo by Larry Price.

85: © 1991, Condé Nast. Photo by Thomas Iannaccone.

93: Courtesy of Jennifer Esperanza.

99: Courtesy of Jamie Okuma. Photo by Cameron Linton and Corel Taylor.

101: Courtesy of Winifred Nungak.

104: Courtesy of Nicholas Galanin.

106, 130: Courtesy of Thosh Collins.

109 (top): Courtesy of Louie Gong. Photo by Victor Pascual.

109 (bottom): Courtesy of Museum of Arts and Design.

111: © 2008 Museum of Arts and Design. Photo by Matthew J. Cox.

112: Courtesy of Rico Worl.

113: Courtesy of Douglas Miles.

115 (top): Courtesy of Kevin Pourier.

117: Matika Wilbur Photography for Project 562, www.project562.com.

121–122: Courtesy of Greg Hall.

123: Courtesy of Kristen Dorsey.

125: Courtesy of Shayla Blatchford. Model: Juanita Christine.

126–127: I.M.N.D.N.–Native Art for the 21st Century.

128: Courtesy of the Fabric Workshop and Museum. Photo by Will Brown.

129: Courtesy of the Burke Museum of Natural History and Culture. Photo by Richard Brown, richardbrownphotography.com.

131: Courtesy of David Gaussoin and the Museum of Indian Arts and Culture. Model: Tazbah Gaussoin.

135: Courtesy of Barry Ace. Photo by Rosalie Favell.

NATIVE FASHION NOW
NORTH AMERICAN INDIAN STYLE

accompanies the *Native Fashion Now* exhibition, organized by the Peabody Essex Museum, Salem, Massachusetts.

EXHIBITION ITINERARY

Peabody Essex Museum, Salem, Massachusetts
November 2015–March 2016

Portland Art Museum, Portland, Oregon
May 2016–September 2016

Philbrook Museum of Art, Tulsa, Oklahoma
October 2016–January 2017

National Museum of the American Indian, Smithsonian Institution, New York
Winter 2017–Summer 2017

This exhibition and book were made possible in part by a grant from the Coby Foundation Ltd.

 THE COBY FOUNDATION, LTD.

(cover)
Orlando Dugi
(born 1978, Diné [Navajo])
Dress, headpiece, and cape,
"Desert Heat" Collection, 2012;
Courtesy the designer,
Photo by Thosh Collins. Model: Louisa Belian.

(back cover)
Jamie Okuma
(born 1977, Luiseño/Shoshone-Bannock)
Boots, 2013-14
Glass beads on boots designed by
Christian Louboutin (born 1964, French)
Peabody Essex Museum,
Salem, Massachusetts,
© 2015 Peabody Essex Museum.
Photo by Walter Silver.

Published in 2015 by Peabody Essex Museum and DelMonico Books • Prestel

PEABODY ESSEX MUSEUM
East India Square
Salem, Massachusetts 01970
978-745-9500
www.pem.org

DELMONICO BOOKS
an imprint of Prestel, a member of
Verlagsgruppe Random House GmbH

PRESTEL VERLAG
Neumarkter Strasse 28
81673 Munich
Tel.: +49 89 4136 0
Fax: +49 89 4136 3721

PRESTEL PUBLISHING LTD.
14-17 Wells Street
London W1T 3PD
Tel.: +44 20 7323 5004
Fax: +44 20 7323 0271

PRESTEL PUBLISHING
900 Broadway, Suite 603
New York, NY 10003
Tel.: +1 212 995 2720
Fax: +1 212 995 2733
E-mail: sales@prestel-usa.com

www.prestel.com

EDITED BY
Sophia Padnos

DESIGNED BY
Abbott Miller and Kim Walker, Pentagram

PRODUCTION BY
Luke Chase, DelMonico Books • Prestel

ISBN 978-3-7913-5469-9 [hardcover]
ISBN 978-0-8757-7230-1 [softcover]

Printed in China

Library of Congress Cataloging-in-Publication Data

Native fashion now : North American Indian style / by Karen Kramer; with contributions from Jay Calderín, Madeleine M. Kropa, and Jessica R. Metcalfe, Peabody Essex Museum, Salem, Massachusetts.
 pages cm
 "Exhibition itinerary: The Peabody Essex Museum, Salem, Massachusetts, November 2015-Febuary 2016".
 Includes bibliographical references and index.
 ISBN 978-3-7913-5469-9
1. Fashion design–United States—Exhibitions.
2. Indians of North America—Clothing—Exhibitions.
3. Indian artisans—United States—Exhibitions.
4. Indian art—United States—Exhibitions. I. Kramer, Karen, 1971- II. Calderin, Jay. III. Kropa, Madeleine M. IV. Metcalfe, Jessica R.
 TT502.N37 2015
 746.9'20747445--dc23
 2015007633